MW00582902

GHOSTS OF THE NORTH CAROLINA PIEDMONT

GHOSTS OF THE NORTH CAROLINA PIEDMONT

HAUNTED HOUSES AND UNEXPLAINED EVENTS

FRANCES H. CASSTEVENS

HAUNTED America

Published by Haunted America
A Division of The History Press
Charleston, SC 29403
www.historypress.net

First published 2009
Second printing 2012

ISBN 9781540219725

Library of Congress Cataloging-in-Publication Data

Casstevens, Frances Harding.
Ghosts of the North Carolina Piedmont : haunted houses and unexplained
events / Frances H. Casstevens.
p. cm.
Includes bibliographical references.
ISBN 9781540219725
1. Ghosts--North Carolina--Anecdotes. 2. Haunted houses--North Carolina--
Anecdotes. 3. Haunted places--North Carolina--Anecdotes. 4. Parapsychology-
-North Carolina--Anecdotes. 5. North Carolina--History--Anecdotes. 6. North
Carolina--Biography--Anecdotes. I. Title.
BF1472.U6C376 2009
133.109756'5--dc22
2008050489

*To my friend and fellow author Lynn Salsi,
who understands the toil of creation, the humiliation of rejection
and the joy of having a manuscript accepted for publication.*

There are more things in heaven and earth, Horatio,
Than are dreamt of in your philosophy.
—Hamlet, *William Shakespeare*

CONTENTS

CONTENTS

ACKNOWLEDGEMENTS

This book would not have been possible without all those people who shared their stories with me. I hope they will prove as interesting to the reader as I found them to be. I especially want to thank our local ghost hunter, Michael Renegar.

Others who shared stories and experiences are Roy Adams, Caren Casstevens, Danny Casstevens, Andrew Mackie, Cynthia Sue Royal, Kay C. Campbell, Carl Casstevens, Gene Wagoner, Marti S. Utter, Pauline K. Quintal, Richard Poindexter, Clinton Prim, Gilbert Brown and the late Mary Williams Ritchie.

I could never complete any of my books without the help of Betty Kennedy, Reba W. Hollingsworth and the staff of the Yadkin County Public Library. They have earned my thanks and appreciation in many ways.

Please note that all of the pictures included in this book are of the actual people involved and sites where the various events occurred. The sketch of Vestal's Mill, drawn by my daughter Caren, was based on an old newspaper photograph.

INTRODUCTION

After publishing my first book of stories, *Ghosts and Their Haunts: Legends and Lore of the Yadkin River Valley*, many of my readers wanted to know if I was going to write another book. Since I did not want to disappoint them, this book is the result of that demand.

There seems to be no end of stories to the unexplainable experiences that friends and acquaintances, and even strangers, are willing to share. Included in this book are stories of unusual occurrences (some of which might be called ghost stories). Most are previously unpublished in any form, but I have also included a few standard ghost stories: "Bringing Mary Home," "The 'Little Red Man' of Old Salem," "Ghost at Bostian Bridge" and "The Brown Mountain Lights." These were included for the benefit of younger readers who may never have read them before.

It does seem that after death, something remains on this plane of the deceased and the events that occurred, especially tragic events, such as murder and suicide. Whether you believe in ghosts or not, many people have experienced things that simply cannot be explained, at least not by current technology.

I cannot vouch for the authenticity of all of the stories. Some were shared by people whom I know to be honest. Some are experiences from within my immediate family. When possible, I have included factual information about people, places and events. While some events, whether truth or fiction, cannot be authenticated, if they are not written down they will be lost forever.

Thus, in my desire to preserve these stories of haunted houses and other unexplained events, I must leave it to the reader to decide the validity of each.

Frances Casstevens
fcasstevens@yadtel.net

THE LEGENDS OF BOOGER SWAMP

As long as those now living between Center Church and Harmony Grove Church can remember, on the road between the two churches there has been a swampy area known as "Booger Swamp." The *booger* part of the name came from the ghost or specter that was often seen in that area of the swamp. For many years, local legends were repeated that that area of the swamp was haunted by a ghost. The legend grew and the stories of travelers seeing ghosts or of hearing strange noises multiplied. The stories about how Booger Swamp got its name are inseparable from the stories of ghosts, strange noises and mysterious lights.

Booger Swamp Road exits on old Highway 421, just past the city limits of Yadkinville at Harmony Grove Friends Church. It winds northward past the Harmony Grove Friends Church Cemetery. A hundred years ago, the road was bordered by dense woods. A few miles from the cemetery, the woods are bisected by a sluggish, slow-moving stream that, after a heavy rain, spreads out across the land to create a boggy swamp.

Some people believe that by the late 1800s or early 1900s, the name Booger Swamp had already been given to this wild, swampy area. The old dirt road (SR 1381) ran from Yadkinville to the Center community and thence to Jonesville through the swampy area.

Not surprisingly, the area known as Booger Swamp has fascinated area residents for years. When Center Methodist Church sponsored a short story contest, the winning story by Christina Casstevens was about how Booger Swamp got its name.

Another young man, Brian Holcomb, submitted an essay on the subject to the Tar Heel Junior Historians of Forbush High School. Brian attempted to explain how the swamp got its name. According to information he obtained from his grandmother, a man was riding past the swamp at night and some "creature" jumped onto his

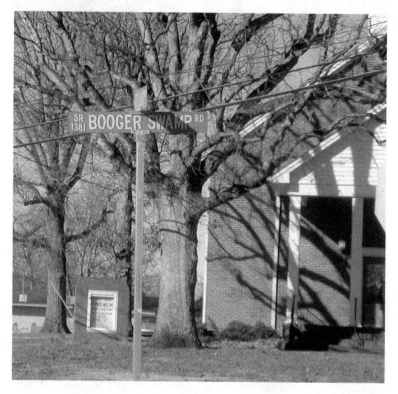

This sign at Harmony Grove Church shows the road named after Booger Swamp.

horse behind him or landed on his back. Terror stricken, the man spurred his horse and raced for home, but the creature was gone by the time he reached his home and told his wife, "There's boogers back there." Most of Holcomb's extremely well-written story is a fictional account of encounters with the "booger" in the swamp, as experienced by several different people over a period of many years. Using the local colloquialisms, Holcomb presents a readable and interesting look at the local people and their way of life in rural Yadkin County as it was in the nineteenth century.

People have always feared swamps. The land is unstable and unpredictable. It is dangerous to go into a swamp. Swamps are inhabited by poisonous snakes and other creatures, such as alligators, that cannot be seen in the dark water. Death is certain if

even a large animal or a person steps in quicksand. Probably many stories and legends were told about swamps to alert people to the dangers and to frighten them away. There are numerous stories about the Great Dismal Swamp and people who have disappeared there. Similarly, there are stories of people who became lost in Booger Swamp and were never found. None of these stories about Booger Swamp has been substantiated by documentation.

Swamps were also good places to carry out clandestine or illegal activities. During the days of Prohibition, swampy areas provided excellent hiding places for illegal distilleries. One such illegal distillery reportedly operated in Booger Swamp. The whiskey makers put out the story that the swamp was haunted to keep out the curious people and law officers. This seems more plausible than some of the other stories.

The Booger Swamp area was also used for other clandestine activities. According to a story that Brian heard from Faye Harrison, there was a place down in the woods where men went to drink and play poker. One night, someone heard a strange noise. It could have been a hoot owl, a panther or a wild dog. The sound, however, frightened the men and they abandoned their card game. They later said that they had heard a ghost or a "booger" in the swamp.

Brian also heard the old story that in the days before automobiles, when people traveled by wagon down the road through the swamp, the devil would jump on the tongues of wagons and ride with the terrified passengers for some distance.

Judy Comer told the story of two little girls who went into the swamp. They came out to report that they had seen a dense, black fog. The fog seemed to have the shape of some monster.

Another tale was told about a man who became demented and wandered off into the swamp. He was never seen again and presumably died there. Soon stories circulated that his ghost had been seen moving about through the thick brush and brambles. Some brave souls who did venture into the swamp claimed that they saw strange sights and heard weird noises, which they attributed to the ghost of the missing man.

One story that has circulated in the community was about Joe Welborn (1901–1964). Welborn owned the local automobile

GHOSTS OF THE NORTH CAROLINA PIEDMONT

dealership and a ten-acre tract in the swampy area. An elderly lady wandered away from home and a search party was organized to find her. Eventually, the search centered on the land in the swamp owned by Joe Welborn.

After the lady had been missing for several days, Welborn decided that he would go and search the swamp for the missing woman. After walking in knee-deep water for several hours, he was about ready to give up when suddenly he came face to face with the missing woman. This unexpected encounter badly frightened both of them.

The woman was dirty, her hair was matted and her dress was torn. Startled by the sudden appearance of an unknown man, the frightened woman began wielding a large stick at Welborn. Shaken by the encounter, and perhaps dazed by the blows he received, Welborn ran back to the others in the search party and shouted, "I saw a booger!" The rest of the search party laughed, but the name Booger Swamp stuck and was quickly picked up by others. The woman was rescued.

BOOGER PROVES TO BE A WOMAN

Another version of this same story was told by Roy Pendry to Max Welborn, the son of Joe Welborn, and then relayed by Max Welborn to Carl Casstevens in 2005. Because it happened in the early part of the twentieth century, this is the only story about Booger Swamp that can be verified. However, this story does not substantiate the legends of either a ghost or a booger.

An elderly woman named Mamie Marler became deranged and ran off into the swamp about 1925. Mamie, born in 1864, would have been sixty-one years of age at the time she wandered off into the swamp. Further details of the story of Mamie's adventure in the swamp or the exact time it occurred could not be determined because only a few issues of the local paper exist for 1925. However, it is known that Mamie had cancer. Perhaps she became disoriented as her mental faculties became impaired. Perhaps she had suffered a stroke or the cancer had spread to her brain.

18

In the middle of the night, Mamie arose from her bed and, seeking relief from pain, wandered away from the house. By morning, her disappearance was made known and a search party was organized. The search party spread out across the town and searched every building. No one had seen her.

Several days passed, and the searchers had begun to search an area west of Yadkinville and along the road that is now called Booger Swamp Road. As daylight waned, one man bravely trudged through the muck and the mire. As the woods grew thicker and darkness descended, he decided he had better return before he became hopelessly lost. He was about to turn back when he saw something white moving through the trees. The man let out a scream and ran back to the road to join the other searchers.

"I saw a booger!" he cried breathlessly, his face white as a new sheet.

The other searchers laughed at him but then reconsidered. "You fool!" the leader of the group exclaimed. "It might have been Miss Mamie. Why didn't you follow the ghost? Why did you leave the swamp?"

The man (perhaps it was Joe Welborn) was not ashamed, and he defended his actions. "It was getting so dark, I was afraid I would step in quicksand or a bottomless pit and could not get out. I thought it best to return and tell what I had seen. We can start out first thing in the morning, when we can see the dangers."

The man's reasoning made sense, as search and rescue equipment was practically nonexistent in 1925. The members of the search party only had lanterns to guide them.

The next morning, Miss Mamie Marler was found. She was filthy, ragged, hungry and wild-eyed. Luckily, even though she had wandered in the swamp for days, she was alive and had suffered only cuts and scratches on her arms and leg. However, she shied away from her rescuers, and it was clear that her mind was deranged. The family wanted to avoid any scandal, but with half the men of the town out looking for her, everyone knew what had happened.

The Marler family was made up of prominent and upstanding citizens. Mamie was the daughter of John G. Marler and Sarah "Sallie" A. Stimpson Marler. John G. Marler served two terms in the

House of Representatives (1870–74) and was elected to the North Carolina Senate in 1874 and again in 1876. John died suddenly in 1877, while serving his second term in the North Carolina Senate. While a member of the House of Representatives, John G. Marler was praised in glowing terms in the *Western Sentinel*:

> *Yadkin County can boast of one of the most zealous and industrious members of the General Assembly in the person of J.G. Marler, Esq., in the House of Representatives. He is not only industrious, but is capable and faithful to the interests of his constituents and the State at large, and is eminently practical in his views of public policy.*

As senator, John G. Marler Sr. was above average in many ways. Another newspaper article ranks him "first upon the floor of the Senate, he has intellect of superior order, which he has ever wielded in the interests of his constituency, he stands boldly forth as their champion, and will at all times give his individual efforts to promote the welfare of the section he represents." The article concluded that the district had "made a wise selection in electing such a fitting and worthy representative."

Even as a young man, Senator Marler was creative. He penned a poem on his twenty-first birthday, which was found years later pasted over one of the pages of a book of Resolutions of the North Carolina House of Representatives. Marler used those books to save newspaper clippings about his political career, and he also inserted some of his own writings. These unusual volumes were donated to the Yadkin County Public Library by the superintendent of Yadkin County schools, Fred C. Hobson, now deceased.

The wife of John G. Marler Sr., Sarah A. Stimpson Marler, lived until 1915. The two of them are buried in the family plot in Yadkinville Town Cemetery.

Mamie Marler was the oldest daughter in a family of seven children. One of the sons, Dr. John G. Marler Jr., practiced dentistry until the 1940s. His little office was near the big maple tree on the east side of the Yadkinville Methodist Church. As a child, Dr. Marler looked at my teeth and found a cavity in one of my baby teeth, but he did not pull or fill it.

Mamie was only thirteen years old when her father died. After the death of her mother, Mamie and her sister, Turnie Blanche, lived with their brother, Dr. John G. Marler Jr. The three siblings lived in a beautiful two-story Victorian house with a wraparound porch at the corner of Main Street and Monroe Street, now the site of the Yadkinville United Methodist Church.

Mamie reportedly had a boyfriend. Her beau, Dr. John M. Phillips, had opened a dental office in Yadkinville after he graduated from Baltimore Dental College. Mamie was remembered as the smarter of the two sisters. Yet neither Mamie nor Turnie married, nor did they want their brother to marry. He was their "security blanket." Despite his sister's objections, John Marler Jr. became engaged to Miss Nora Hamlin. The couple set a date for the wedding. Sadly, it never took place. The Marler girls locked their brother John in a closet to prevent him from meeting his betrothed at the church. Miss Nora Hamlin later married John D. Holcomb, a Yadkinville merchant.

After she was rescued from the swamp, Miss Mamie was taken to the state mental hospital at Morganton, where she remained until her death seven years later in 1932. She was buried with her family in the Yadkinville Cemetery.

Once the home of John D. Holcomb and his wife Nora Hamlin, this house is one of the few stately Victorian houses left in Yadkinville.

Yadkinville Town Cemetery, where members of the Marler family rest.

The remains of what was once a large swampy area called Booger Swamp.

Mamie's brother, John G. Marler Jr., died on August 2, 1944, of atherosclerosis and heart disease. Her sister, Miss Turnie Marler, died at age ninety-seven on July 8, 1964. Her death was attributed to a fractured tibia and fibula and senile dementia.

Were some of the stories about Booger Swamp simply the result of overactive imaginations? Were the stories of ghosts and boogers circulated by those who wished to keep people out of the swamp? At this point in time, it is impossible to know the truth about the things that have been reported.

Update: The Booger Swamp Road has now been paved. It is lined with lovely modern homes. Much of the woods on the north side of the branch have been cleared, and the little stream has been dredged and made deeper so that the water runs in the creek bed instead of spreading out and standing to make a swamp.

But if you believe in ghosts, perhaps you better not walk down Booger Swamp Road in the dark. You just might see a booger.

THE UNFORTUNATE DESERTER

North Carolina was slow to leave the Union. However, once Beauregard's troops fired on Fort Sumter and the fort's defender, Major Anderson, surrendered, North Carolina took sides and left the Union. In this state and throughout the South, young men and boys were anxious to join the Confederate States Army, especially after President Lincoln called for seventy-five thousand troops to put down the rebellion in South Carolina.

Everyone believed that it would be a short war and should be decided in just a few weeks. This was not the case. As the war continued and casualties mounted, more and more people became opposed to the fighting. Reinforcements were necessary to replace those men killed or wounded on the battlefield. On top of that, countless numbers of men on both sides deserted.

Because volunteer enlistment could not replenish the forces, a conscription (draft) law was enacted. The militia and the Home Guard were charged with the task of rounding up both deserters and draft dodgers. Confederate General Robert F. Hoke even came to Yadkin County with a detachment of Confederate soldiers to perform this duty. Some young men resented the draft, while others were opposed to war altogether. Throughout the Piedmont and mountain counties, men hid out in unusual places to avoid being drafted or returned to their units. Some hid under hay in barns, others in the attic of log cabins. A few dug caves into hills or the side of creeks. Some stayed at home to work their farms until the soldiers arrived and then high-tailed it to the woods and hid out until the soldiers left.

A frequently used hideout during the Civil War was Mahaney's Rock, which local residents called Haney's Rock, near South Deep Creek. A man whose occupation was a shoemaker reportedly hid out there to avoid being conscripted into the Confederate army.

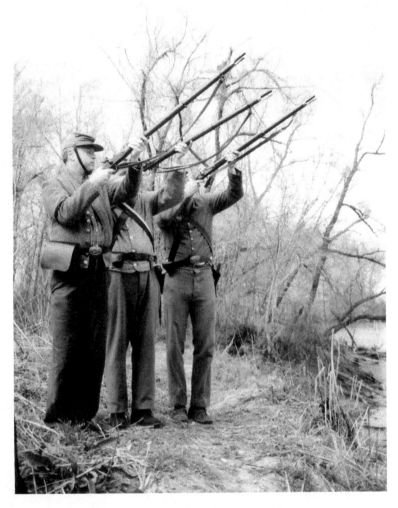

Confederate soldiers preparing to take aim at a captured deserter.

Gilbert Brown, a Yadkin County resident, recently told another story concerning that same spot. A Confederate soldier had deserted and come back home from the battlefield. He soon was captured by members of the Home Guard, and they intended to escort the deserter to the Yadkin County jail. Along the way, the deserter

attempted to get away. The captain of the Home Guard was not in the mood for any resistance. He and his men had other deserters to find. When the man they already had in custody continued to struggle, the captain ordered his men to tie their captive to a tree. They bound him with chains and shot him. Then they callously went on their way and left the soldier to die. According to local legends, as an example to others, this deserter was never taken down but remained chained to the tree until he was nothing but a pile of bones. The chains that bound the unfortunate man were never removed and became embedded in the bark of the tree.

Soon after the deserter's death, apparitions were seen near the tree, believed to be the ghost of the murdered man. The spot is avoided, especially at night, by those who know the story.

A DREAM OR A GHOSTLY VISITOR

A stately old house sits on a knoll back from Old Highway 421, about three miles east of Yadkinville. It was built in 1882 for John Henry Davis (1850–1920). The two-story house was surrounded by the necessary outbuildings: a corncrib, wash house, woodshed, smokehouse and other small buildings that were common until the middle of the twentieth century.

The house and the land passed to John's youngest son, Huston Thomas Davis (1885–1977), after John's death. Huston married Daisy Shermer, and they lived happily for many years. Daisy was born in 1883 and lived until 1969. Her husband, Huston T. Davis, was born in 1885 and died in 1977. After their deaths the house was rented.

Margaret* and her two daughters leased the house about 1978. Margaret slept in a bedroom on the first-floor ell, which opened off the kitchen. Some months after the family moved in, Margaret broke her ankle, and she was bedridden for several weeks while her ankle mended.

A strange event happened one day. Margaret could never decide whether it was a dream or if it really happened. She told her daughters that the door from the kitchen was opened and a small woman, dressed all in black except for a white apron, came into her room. The woman sat down in a rocking chair and began to rock back and forth. After a few moments, the unknown visitor told Margaret, "Don't worry. Everything will be all right." Then the visitor got up, went back into the kitchen and closed the door behind her.

Margaret was dumbfounded. What did the words mean? Was the woman talking about her broken ankle? Or were her cryptic words referring to some other crisis she had yet to face?

Later, Meg, one of the daughters, came to check on her mother. Margaret told her about the strange visitor. "I don't know whether

The stately Davis House does not look haunted.

I dreamed it or whether she was real," she told her daughter. "Did you see anybody come into the house?"

"No, Mama," Meg replied. "I was upstairs in my bedroom studying." She tried to console her mother with, "Maybe it was just a dream."

Meg did not forget what her mother had told her, however. As soon as she could, she asked an elderly relative about the people who had previously lived in the house. Her grandmother had known the former owners, Huston Davis and his wife, Daisy. Meg's grandmother described Daisy Shermer Davis as a small woman who always wore her hair up in a small bun on top of her head. She also remembered that Daisy always dressed in black.

Margaret always wondered whether she was visited by a woman from the past. Her daughter Meg was sure of it.

*The names of the woman and her daughter have been changed to protect their identities. I knew both of them personally.

FOREWARNED IN A DREAM

In her dream, Katie could see the smoke and flames engulfing the DC10 airplane. People were screaming and trying to get out of their seats. Some of the passengers had blood on their faces; others were not moving at all. She could smell gasoline and burning plastic. She watched helplessly as a dense black cloud of smoke came toward her. She could not get her breath.

At that moment Katie awoke from a horrible nightmare. What did it mean? Was it a warning? She was scheduled to take a flight out of Mexico that morning to return to her home in North Carolina. Did the dream mean that the plane would crash? A feeling of impending doom filled her as she snuggled back under the covers and tried to go back to sleep. That day, she could not shake that feeling of looming disaster. Her dream remained vividly in her mind.

It was the summer of 1983. Katie had been very excited about her trip to Mexico. The trip would give her an opportunity to visit some of the most important Aztec and Mayan sites in Mexico and also earn course credits for doing so. As a rising senior at Appalachian State University, she needed to take some summer courses in order to graduate on time. The trip seemed like the ideal solution.

However, the trip proved to be disastrous almost from the start. Recent volcanic eruptions and earthquakes near Mexico City had contaminated the water supply, and there was an outbreak of typhoid fever. Typhoid fever is an infectious disease that causes severe digestive system symptoms. The disease is transmitted from person to person via food or drinking water. The first phase of the disease lasts about a week. During this time, the infected person runs a high temperature and has bouts of sweating, loss of appetite, coughing, headache, constipation and skin symptoms. Children often have both vomiting and diarrhea. In the second phase of two

to three weeks, the patient still runs a very high fever and the pulse becomes weak and rapid. The third week is characterized by severe diarrhea. It can take four or five weeks for the patient to entirely recover. The disease can be fatal.

This was what happened to Katie. She began to run a fever. Soon, she was very sick. Luckily, there was a female doctor staying in the hotel where the students were lodged. With constant care and treatment from the doctor, Katie recovered, but she had lost forty pounds.

After her recovery, Katie looked forward to seeing some of the Mayan pyramids. Unfortunately, by that time she was supposed to return to the United States. She did enjoy a few days in the sun on the beach at Cancun, a modern tourist resort, where she got a nice tan.

The group of students from ASU was to fly from Cancun to Tampa, Florida. From there they would fly to Greensboro, North Carolina. On the night before their scheduled departure, Katie had the horrible nightmare. At the airport, Katie told some of her classmates about her dream. One other person had also had a premonition that the plane would crash. Katie was so afraid of getting on the plane that her classmates had to physically drag her up the ramp. The plane was a DC10, just like in Katie's dream, and she had a seat right in the middle of the aircraft. She was almost hysterical, and she prayed throughout the entire flight. She thanked God when the plane landed in Florida without incident. The first leg of the trip home had been completed successfully. But the journey was not over. There was to be a delay, and the group was free to roam the terminal until it was time to board the plane to take them to North Carolina.

Before boarding their scheduled plane out of Florida, Katie's teacher learned that there was another flight that would get them back to the Greensboro airport much quicker than their scheduled flight. When the teacher told Katie about the other flight, the young student was greatly relieved. This time, she did not hesitate to get on the plane because it was not a DC10 and she had no bad feelings about it. After several hours, Katie and the other students landed safely at their destination.

The strange part of this whole story is that the plane Katie and her group were originally booked to fly home on was a DC10. They took another plane, but their originally scheduled one (the DC10) did crash. It was carrying students Katie had met while she was in Mexico.

When Katie got off the plane at the Greensboro airport, her parents did not recognize her until she ran to hug them. She was very thin and as dark as a Mayan Indian. Only her sky blue eyes were the same. Those eyes glowed with happiness and love. She thanked her guardian angel for allowing her to reach home safely.

Can the future be foretold in a dream? Should we heed the premonitions and those funny feelings we sometimes get? Or is it just coincidence that what we dream sometimes becomes reality? Katie believes that she was warned in her dream, and that her life was spared because of that very vivid, nightmarish dream.

GHOSTLY LIGHT IN THE MOUNTAINS

When I was twelve years old, I attended Camp Shirley Rogers, the Girl Scout camp near Roaring Gap. One of the highlights of the week for my group was a short hike that began late in the afternoon and lasted into the early hours of the night.

After walking several miles from the camp, we were glad for a chance to sit down and rest our tired feet. The sun was slowly sinking behind the mountain in the west. Below, we could see houses that looked as small as those used in the game of Monopoly. To the east we could see Pilot Mountain, an unusual peak that had served as a guide for Indians and pioneers alike.

For supper, the camp chef had provided each girl with a peanut butter and jelly sandwich, which we all carried in little brown paper bags. We each toasted marshmallows on a long stick held over the fire. Occasionally, there was a squeal as one of the girls dropped her marshmallow into the fire.

As it grew darker, Jane, one of the most popular counselors, asked, "Do you all want to hear a ghost story?"

We jumped up and down and cried, "Yes, please tell us a ghost story."

"All right, but you must sit down and remain quiet," Jane ordered.

We did as we were told and waited eagerly to hear the story.

Jane began,

A long time ago, there were not many people in this area. Families were isolated, and in order to survive, they became self-sufficient. One of those who settled in this area was a Mr. Jim Smith. He came down from Virginia and brought his family with him. He also brought Jake, an old slave he had inherited from his father. When he inherited Jake, Mr. Smith offered the old slave his

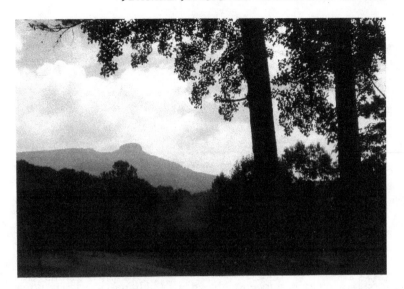

Pilot Mountain looms over the Piedmont.

freedom, but Jake had been with the Smith family since before Jim was born. The Smiths had become his family and he would protect them with his life.

The Smiths, with the help of Jake, built a one-room log cabin. During the spring and summer months, everything was fine. Then, in the middle of an extremely cold winter, the food ran out. Rather than see his family starve, after a heavy snow, Jim Smith took his flintlock musket and went in search of game. Night came and he did not return. Several days passed, then weeks and still Smith did not return. Without food, the family he had left in the cabin died of starvation.

Eventually, another family occupied the Smiths' cabin. The new owners began to see a light moving back and forth down the mountain as if someone was carrying a lantern to light their way. Other people also saw the light, but no one could explain it.

Finally, an old woman who lived a short distance from the Smiths' cabin said she knew the origin of the light. The woman had known the Smith family, and she remembered that, except

for Mr. Smith, they had all been found dead inside their cabin. It was believed that he had lost his way and had frozen to death in a blizzard.

"Why, it's clear as the nose on your face," she told the new owners. "That light you saw is Old Jake out looking for his master. He was a faithful old slave, and he cannot rest until he finds his master." That made more sense than any other explanation.

Jane assured us girls that ever since then, when strange lights were seen moving across the mountains near Roaring Gap, no one questioned their origin. She told us, "Everyone knows it is Old Jake looking for his master. So don't be scared if you see his light."

Each girl began to look at the dense woods down the mountain for a moving light. Sure enough, we saw a light moving slowly along a path that led down to the valley. Almost in unison, we screamed and pointed to the light that moved back and forth, as if someone was carrying a lantern.

At that time, I was positive that I had seen the ghost of Old Jake looking for his master. As an adult, I have wondered if it was just one of the other counselors trying to scare us. I guess I will never know for sure.

A MISCHIEVOUS WITCH

M y cousin Richard shared the fragments of a family legend he had heard about an encounter between two girls of a family in the Smithtown area of Yadkin County and a witch. The given names of the girls who were locked in the cellar and their family are fictional; the name of the witch is not.

Two teenage girls, thirteen-year-old Catherine and her sister, fifteen-year-old Betty, did not come in from doing their farm chores before their evening meal one night. This was a very strange occurrence. The girls had never missed a meal before. After some time had passed and the girls did not return, their parents and siblings began to search the house for them.

"Where are those girls?" asked the father of the missing pair. It would soon be night, and it was not safe for young girls, or anyone for that matter, to be outside in the woods at night. There were many dangers from humans, wild animals and the environment. Men were known to kidnap young girls they wished to marry, if they could not get parental approval. Wolves roamed the country and sometimes carried off domestic animals. Sometimes babies or small children became prey. There were swift-flowing streams and deep ponds that could claim the life of anyone who could not swim. Some of the old folks said there were unseen dangers as well.

The father did not want to show fear, but he was beginning to be concerned about the whereabouts of his daughters. "I bet they are hiding so they won't have to do their chores." He looked at the younger children and asked, "Do any of you know where they could be hiding?"

"I don't know, Pa," replied Johnny, one of the younger boys. "Why should they be hiding? I think they have already done most of the work they were supposed to do."

"Well, where are they? We've looked all over the house and in the barn."

Just then the father and his son heard a muffled thumping sound. It seemed to be coming from beneath the house. "Do you hear that noise, son?"

"Yes, I do," replied the boy, "and I think I hear someone crying."

Johnny and his father ran around the side of the house to the cellar door. The sounds grew louder as they approached. When they reached the cellar door, they could see that it was locked on the outside. The father raised the heavy oak bar that prevented the doors from being opened and set it down. Then he opened the double doors and peered into the darkness. His two missing daughters were crouched on the steps, their eyes red from crying. "What are you doing in the cellar, Catherine?" he asked the oldest of the girls.

Catherine sniffled and looked at her father. "It was the witch, Pa. She lured us down here and made us drink the wine. Then, when she heard you calling us, she disappeared in a puff of smoke."

The girls reeked of wine as they staggered up the steps and out the cellar. Their father could see that they were quite inebriated, but he did not believe their story. Someone had played a trick on them and locked the door from the outside. But who could have done such a terrible thing? His younger children were not strong enough to lift the bar, and he didn't believe they would do such a thing on purpose.

The children were forbidden to go down into the cellar without their parents. Dried fruits and vegetables needed for the family to survive during the winter months were stored there, as well as the wine their mother made from wild muscadines and scuppernongs. The cellar also harbored poisonous snakes and deadly spiders.

"It was awful, Pa," said Catherine, big tears running down her pink cheeks. "We wanted to get out, but when we tried to leave, the door was locked from the outside. We don't know how that happened."

The family was puzzled. Who would have locked these young girls in the dark cellar and left them? Surely, only a witch would do such an evil deed, but witches did not exist, did they? The general consensus was that the girls had made up the story of the witch to cover their guilt at being caught drinking in the wine cellar. But how did that explain the door being locked from the outside?

Perhaps they were telling the truth, or what they believed was the truth. Someone had locked the cellar door from the outside

after the girls had gone into the cellar. Their parents had not done it, and none of the rest of the family admitted to doing it. But, undoubtedly, someone had locked them in. As to whether that same person had been in the cellar with the two girls is debatable. If what the girls said was true, that person was a witch. Could that witch have been their neighbor, Angeline Lineberry?

Angeline was the daughter of Solomon Lineberry, a stonemason. Some of the Lineberry descendants passed down stories about Angeline, who was said to be a "witch." Reportedly, she could also tell fortunes, but whether she was proficient in other areas of the occult is unknown.

As late as the nineteenth century and even into the early years of the twentieth century, with the scarcity of doctors, every community relied on a "witch," a "wise woman" or a "midwife." These women were skilled in the healing arts and in assisting at births. Some of these women were also sought for love potions, as well as potions to induce a miscarriage.

Little is known about Angeline. In the mid-1850s, Angeline's family had moved from Randolph County to the area between Smithtown and East Bend in Yadkin County. According to Yadkin County census records, Angeline was born about 1844. She was the youngest girl in a family of nine children. (For more information, see my book, *The Descendants of Solomon Lineberry*.) Her death certificate (recorded in Yadkin County, North Carolina) states that she died on April 9, 1927, at age eighty-three and was buried in the cemetery at Shady Grove Church near East Bend.

Angeline was marred twice. She first married John McDowell in 1866. After his death, she married George Washington Randleman in 1909. In 1862, Angeline gave birth to a daughter named Catherine. Angeline had two sons by her first husband.

The story about the two girls being locked in the cellar eventually may have merged with stories about Angeline. Whether Angeline was involved with the girls in the cellar can never be proven, but something undoubtedly did happen for fragments of the story to be remembered. True or not, the story of the girls in the cellar was passed down to descendants living in the twentieth and twenty-first centuries, as were stories about the witch, Angeline Lineberry.

MYSTERIOUS NOISES HEARD IN THE A.G. SHORE HOUSE

O n Holcomb Road, just north of Mitchell's Chapel Church, stands a large, two-story house that is slowly falling in on itself. The once beautiful house was designed with a three-bay, shed roof porch that sheltered the front door. Two-over-two, double-hung sash windows added to the beauty of the house. A small pent gable framed the center bay on the second story. The main block of the house was capped by a low hip roof. The house is larger than it appears, for there once was a two-story ell at the back. Only one chimney rose at the intersection of the two blocks.

With no occupants for many years, the house was exposed to the elements through the broken windowpanes. The roof has caved in and both the front and back porch roofs have collapsed and rotted away. A house that was once a cherished home is now a decaying shell with a sad and tragic history.

Aquilla Glen Shore was born in 1874. On December 30, 1906, he married Dora Octavia Casstevens, the daughter of William H. Asbury Casstevens. Just a few months before her marriage, Dora's father deeded her 10 acres of land. After she married, Dora and her husband probably raised tobacco on those 10 acres. In 1912, Shore purchased 2.5 acres from his wife's father and built this once beautiful house as a home for his wife and their growing family of children. (See Deed Book 7, Register of Deeds Office, Yadkin County, North Carolina.)

Shore was a small man, but he loved to play the fiddle.

It would seem that Glen and Dora were set to live the good life. But all was not as it seemed in the Shore household. Velma, their oldest child, was a beautiful little blonde-haired girl. Born in 1907, Velma died in 1909 when she was only two years old. At the time of Velma's death, their second daughter, Ruby (born 1908, died 1980), was just a baby. The parents were devastated by the death of

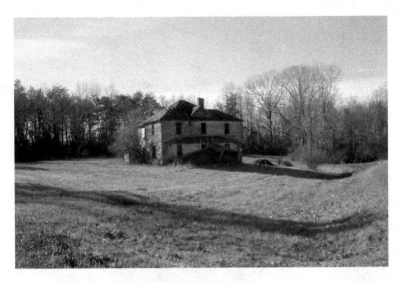

Ruins of the Aquilla Glen Shore House.

their first child. They had only a picture of the little girl to console them. However, as the years passed, seven more children were born to the couple, and the dead girl was eventually forgotten.

Over the next twenty years, A. Glen Shore and his wife Dora borrowed money and mortgaged their land. All of the mortgage deeds and deeds of trust were marked "cancelled" except a deed of trust to F.W. Hanes, Trustee, dated 1926, recorded in Mortgage Deed Book 33. In 1929, the Great Depression struck, the stock market crashed and the economy suffered throughout the country. That may have been the reason Shore lost his house. His crops may have failed, or there may have been other contributing factors. After the foreclosure, Shore and his family had to move to another place. The house he had so lovingly built was bought by another landowner and was used for renters and sharecroppers. So many people lost their homes during the Depression that the next generation tried to avoid getting into debt.

Ruby Shore (wife of Tom Casstevens), my mother-in-law, enjoyed telling stories about growing up in the old A.G. Shore House. She remembered hearing strange noises in the house, but their origin was never discovered. On many occasions, someone could be heard

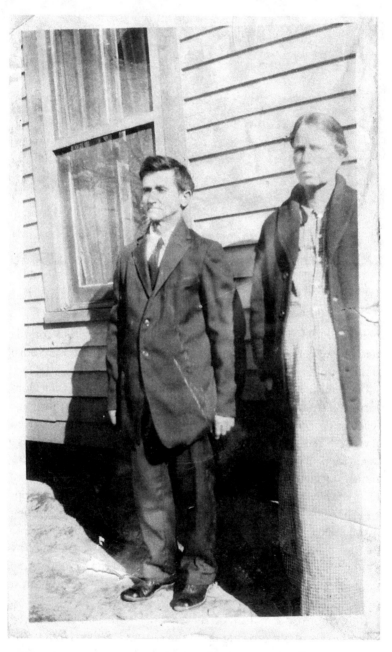

Aquilla Glen Shore (1874–1947) and his wife Dora (1882–1949).

coming up the stairs to the second floor, but no one was ever seen. Eventually, the family members became so accustomed to the ghostly footsteps ascending the stairs that they ignored the noises.

Ruby also remembered that a door to one of the upstairs bedrooms would never stay closed, even when it was locked. Rosalyn, her younger sister, remembered hearing stories of some ghost horses that would race around the tobacco barn at night when Shore and his boys were there fueling the burners to cure their main cash crop.

Were the footsteps made by one of the boys playing tricks on the family, or were the noises the product of an overactive imagination? No one is alive to tell. The house will not divulge its secrets. Soon it, too, will return to dust just like those who once occupied it. However, footsteps and doors that won't stay shut are typical of ghostly activities.

THE HAUNTED BUNGALOW

K im, a distant relative of mine, and her husband bought a house in the Ardmore section of Winston-Salem near North Carolina Baptist Hospital. It is a typical 1920s bungalow. The white frame house has two stories, and the typical front porch is supported by tapered posts that rest on brick supports.

The house has a large, shady backyard surrounded by a tall board fence in which Kim's two dogs roam. The gate is kept locked to ensure that the dogs don't get out. One day, Kim was weeding some of the flowerbeds in the backyard when she thought she heard someone talking. She turned her head to see if it was her husband and she thought she saw him sitting on the back porch talking to someone, perhaps on the telephone. Unperturbed, she returned to her weeding. After a few minutes, she stopped working in the yard and went into the house. She asked her husband if he was talking to his family on his cell phone. He said, "No." Then she asked who he had been talking to, and he replied, "I have not been talking to anyone." In fact, he said he had not even been out of the house or on the back porch. She was puzzled. If it was not her husband she saw and heard, then who was it? Was it an apparition or a figment of her imagination?

After talking with neighbors, Kim learned that the original owner of her home had died in a bedroom of the house. She also learned that the previous owner had kept a "victory garden" during World War II. She reasoned that he must have spent a lot of time out in the backyard.

Other strange things occurred in the house from time to time. On two different occasions, Kim came home to find the water running in the bathroom sink. It was not a slow drip but was running at full speed. The handle had been turned to the "on" position. Neither she nor her husband had left it on, and she could find no explanation as to why the water was on.

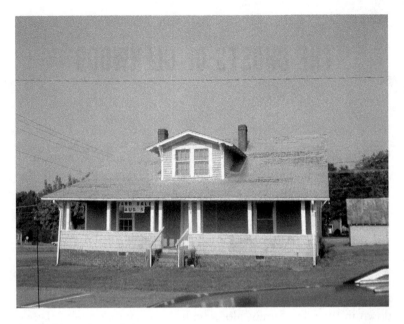

A typical bungalow-style house.

On other occasions, she heard loud noises, as if something had fallen off the wall and crashed to the floor. Once, this kind of sound was also heard by her husband and both of her dogs. She was upstairs with one of her dogs when she heard the sound. The sound startled the dog and he jumped up. As she and the dog raced down the stairs to see what had happened, the other dog met them at the bottom of the steps. She and her husband searched every room and every closet but could discover nothing out of place. Unexplained noises have occurred several times, but this time it was much louder.

Months later, Kim discovered that her mother's mandolin, which had been sitting on top of the armoire/TV center, had somehow fallen behind it. She could not understand how this had happened. Perhaps her mother was sending her a message? The fall of the mandolin could possibly explain some, but not all, of the strange noises she has heard in the haunted bungalow.

THE GHOSTS OF GLENWOOD

The most beautiful antebellum home in Yadkin County, and
perhaps in all of North Carolina, is Glenwood. Just off the
Flint Hill Road, the house is about a mile and a half from the
Yadkin River. A massive, fortress-like structure, Glenwood can still
be seen today from the road. The house is listed on the National
Register of Historic Places.

Tyre Glen married the beautiful Margaret Bynum in 1836.
The newlyweds spent their honeymoon in New Orleans, where
they had their portraits painted. Those portraits have been passed
down in the Glen family, along with the story that one of Tyre's
daughters, in a fit of anger, slashed her father's neck in the portrait
with a knife.

Tyre and Margaret Glen lived in Mississippi for several years,
where he made a fortune as a slave trader. The couple returned to
Surry County (now Yadkin), North Carolina, to settle down. Glen
acquired a vast tract of fertile land on which to build a mansion for
his bride. The mansion was constructed with slave labor. The slaves
lived in whitewashed cabins along the road from the main house
to the site of Glen's ferry on the Yadkin River, over a mile away.
At one time, Glen owned six thousand acres and as many as 350
slaves, but he did not hold with secession. He was an enigma—a
wealthy plantation and slaveholder who was a Union supporter.

Before building Glenwood, Glen and his wife lived in a smaller
house nearby, which was built by Thompson Glen in 1817. The
Thompson Glen House has been extensively renovated and is still
occupied.

Glen began construction of his house about 1841 and probably
finished about 1851, according to his son, Tyre Glen Jr. He reportedly
spent five years selecting the right lumber and other materials.
Because Glen selected his building materials with such care, the

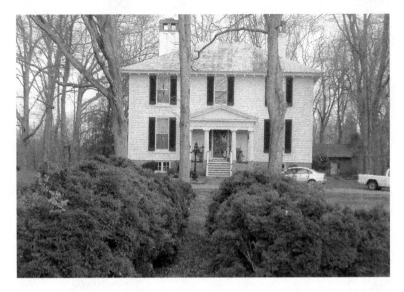

The front of Glenwood, the Tyre Glen mansion.

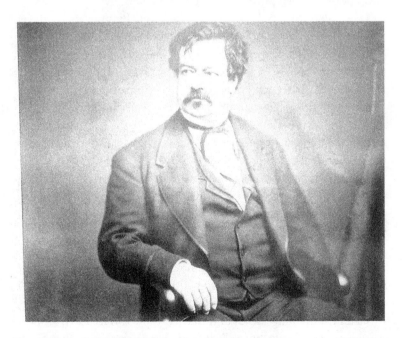

Tyre Glen, a slave trader and wealthy plantation owner, was also a Unionist. *Courtesy of the Yadkin County Historical Society.*

house has stood for over 150 years and has been continuously occupied. Tyre Jr. recalled his father saying that he "was putting it [the house] there to stay." Tyre Jr. recalled that Glenwood "was all built by hand. The materials that went into the house were cut and hand-finished, from the cherry doors, to the forest pine floorboards, to the soapstone fireplace facings." A foundation of soapstone, eighteen inches wide, elevated the wooden joists and floors above the ground.

The front of the house is approached by a circular drive. Ancient boxwood flanked a walk to the current road. The front entrance is covered by a one-story portico supported by Doric columns. Two chimneys emerged from the hip roof of the house.

Each of the fifteen rooms in the house is twenty feet square, with fifteen-foot-high ceilings. All of the rooms are plastered and have large shuttered windows holding six-over-six windowpanes. The solid red cherry doors are two inches thick. The front and back doorknobs and bell pulls are made of German silver.

Tyre Glen Sr. and his wife, Margaret Bynum, had eleven children—eight girls and three boys. Before the Civil War, the Glen family lived a life of opulence and extravagance. Glenwood hosted visits by governors, judges, lawyers, politicians and preachers. It was a popular place for Judge Richmond Pearson and the students who attended his law school to visit and meet important people, such as Governor Zebulon B. Vance and Stephen A. Douglas Jr., son of Lincoln's opponent in the Lincoln-Douglas debates during the presidential campaign of 1860.

When a party was in progress, the thirteen- by forty-foot hallway was cleared of all furniture to allow space for dancing. With music provided by the slave fiddlers and musicians who stood on the landing above the main hall, Glen's party guests danced to the "Virginia Reel," the "Square Dance" and even the new waltz.

At the end of the hall is a wide staircase that ascends to the second floor, where the bedrooms contained large, four-poster beds made of mahogany, walnut or cherry. Other bedroom furniture included washstands, dressing tables and marble-topped bureaus with both regular drawers and "secret" drawers for hiding valuables. Some of the furniture had to be constructed by plantation slaves inside

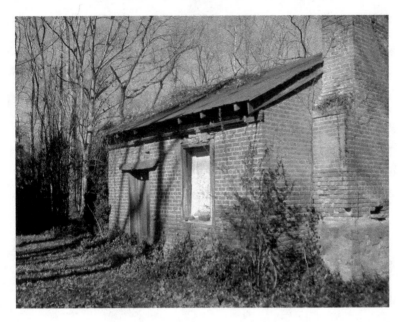

The remains of the brick kitchen house behind the main house at Glenwood.

the room for which it was intended because it was too large to go through any of the doors.

Cooking was done in a brick building only a few steps away from the main house. It still stands and is unique because it is of brick rather than log construction.

The library at Glenwood contained thousands of books, many quite old even in the 1860s. The library also included a set of Godey's *Lady's Book*, with issues from 1837.

At the back of the long hall, a door opens to reveal stairs that go down to the basement. Few houses constructed in this area during the nineteenth century had full basements. Here, the size of the basement rooms mirrors those rooms on the first floor, with a wide hallway flanked by two rooms on each side. One room in the basement was used to store the china. Another room was the apple room, which was filled with barrels of apples. The whiskey room was stocked with barrels of rum, brandy and cherry bounce.

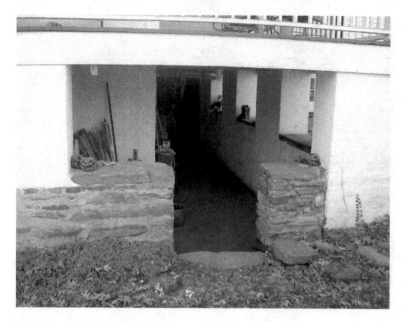

The outside entrance to the full basement at Glenwood.

A mysterious room in the basement has a board on the bottom of its door, which only swings inward. The opening created is just wide enough to allow a tray of food to be passed through. The inside of the door is covered in a sheet of metal, and there is no doorknob on the inside. I believe that this room was where the slaves were kept when punishment was required. There was only a small window and chains were attached to hooks set into the walls. Thus shackled, a person being held in this room had no chance of escape. Some people believe that Glen was cruel to his slaves, and the "punishment room" would seem to support this. Glen may have had to maintain discipline among the slaves, and there were many methods to accomplish this.

Others believe that Glen was never cruel to any of his slaves. One descendant reported that Glen once caught his overseer whipping a slave with a stick. This infuriated Tyre, and he grabbed the stick from the overseer's hands and gave him several blows with that same stick. Then Glen fired the overseer. The overseer

vowed to "get even," and he ambushed Glen one night as the plantation owner stopped to open a gate. The former overseer struck his employer on the head with a club and was about to strike again when "Uncle Nick," a trusty old slave, intervened and the overseer rode away. "Uncle Nick" picked up his unconscious master and carried him home as he bled profusely from a wound on his head. Although Glen recovered, it was believed that the head wound shortened his life.

GHOSTLY APPARITIONS

With such a setting, and over so many years, Glenwood more than likely would have acquired a few ghosts. Many people have testified that the face of a woman had been seen looking out of one of the front windows. Later occupants told stories of either seeing one of the Glen women on the stairs or sensing that someone was there.

The big piano that graced the parlor during Glen's time remains in the house. When his children lived there, this piano was played on many occasions. Later occupants believed they heard the piano being played by the spirits of either Margaret Bynum Glen or her daughter Laura, who died in her early twenties.

Hunters and local people have reported seeing a slave hanging by his neck in the trees behind the house. The origin of this story may have some factual basis. Even though Tyre Glen was a Union supporter, he did not want anyone, Yankee or Confederate, to take away his money and silver. On one occasion when Federal troops were near, Glen, accompanied by a faithful slave, hid his valuables. The slave was captured and tortured by the Yankees, but he would not reveal the hiding place of Glen's wealth. A second time, when danger threatened Glen's wealth, he tried to get the slave to go with him to hide it. However, the old slave begged his master to let him stay behind, and Glen, remembering what the old slave had already suffered, did not insist on his company. When General George Stoneman's Union cavalry raided the area in the spring of 1865, Glenwood was spared, and Glen managed to save the family silver from the Yankees.

HAUNTED STORAGE BUILDING

What could not be raised on the plantation, Glen ordered from Philadelphia. The supplies were transported from there by wagon and were stored in a gigantic storeroom near his house. After the war, the storage room was converted into a store. The former slaves told many stories about this place. One of their tales was the legend of a man who killed another there at the store. The murderer was bound in chains, but he somehow managed to escape. The black folks said that you could "still hear the chains rattle on the stairs, if you passed by" at a certain hour of the night.

This old storehouse no longer exists. The brick kitchen behind the main house remains untouched, except that a tin roof has replaced its wood-shingle roof, which was set on fire by a slave.

One descendant visited the stately mansion several years ago and took several exterior views of the house. When she had the pictures developed, all were marred by a white haze. Was it bad film, bad developing or was there some ghostly "ectoplasm" enveloping the house? When I visited the house recently, another person who was there at the same time took several photos that showed ghostly "orbs" floating in some of the rooms.

The house is currently occupied and is not open to the public except by special invitation.

A STRANGE EVENT AT THE JOYCE-HOLTON-PRIM HOUSE

Yadkin County was formed from Surry in the fall of 1850. A new county seat, located in the center of the county, was established. Initially, county court was held in a store belonging to Theophilus C. Hauser on the western edge of the present town. Hauser's store was about where the auto parts store now sits. Only a few feet away, Hauser's home is still standing. It has been turned into apartments and is not open to the public.

Land was purchased from Robert Mackie for a town that would become the county seat of the newly formed county. The new town would have a courthouse and a jail. Other county government offices were to be located in the new courthouse.

The land for the town was surveyed in the shape of a square, and lots were auctioned off. In the center of the town, a square was reserved for a new courthouse. Originally, the town was called Wilson (for the family of Dr. H.C. Wilson), but when it was learned that there was already a town by that name in the state, the name was changed to Yadkinville.

A few structures built in the 1850s and earlier still remain standing in and around the town of Yadkinville. The two oldest are both outside the original square—the Tulbert House and the Joyce-Holton-Prim House. Some people, including historian Lewis Brumfield, believe that the Joyce-Holton-Prim House was originally a tavern, or grog shop, and that it was in operation even before streets and lots for the new town were surveyed. Although neither the date of construction nor the builder of this house can be verified, it may be one of the oldest buildings in Yadkinville. The structure sits across West Main Street from the Yadkinville United Methodist Church.

Mrs. Sarah Stone Joyce, the widow of Absalom Joyce, moved from Rockingham County to the new county seat with her three

sons and one daughter. It can be verified that Mrs. Sarah Stone Joyce purchased ten acres of land from Oliver P. Hough in 1854 for $600. At a time when farmland sold for as little as $1 per acre, this property probably had one or more buildings already standing on it when Mrs. Joyce bought it.

The move to the new county was probably motivated by new job opportunities for her boys. Her oldest son, William A. Joyce (born 1832), was a graduate of the University of North Carolina at Chapel Hill. He became deputy clerk of court for Yadkin County. He was also a lieutenant colonel in a Yadkin County regiment of the state militia. William A. Joyce is one of the characters in *A House Divided* by Ben Ames Williams. In the novel, Joyce was told about the shootout at the Bond Schoolhouse. In reality, Joyce was a participant and was listed as a witness in the indictments of Jesse Dobbins and others for murder.

Her second son, Robert H. Joyce, born about 1836, was employed as a stagecoach driver. Her youngest son, A. (Absalom/ Abner) R. Joyce, was born about 1841. In the 1860 census of Yadkin County, he was listed as an eighteen-year-old medical student. In 1871, A.R. Joyce married Elizabeth E. Jenkins in Yadkin County. The couple moved to Surry County, where they lived until Elizabeth died in 1927 and A.R in 1928. Both are buried at Mt. Pleasant Baptist Church cemetery, in Bryan township, north of Elkin. Mrs. Joyce's only daughter, Wilmuth (born 1839, died 1925), married Dr. Lewis York. She and Dr. York had a large family.

In a foreclosure sale, Mrs. Joyce lost the house and it passed through several hands. At the sale in 1881, the Joyce House was purchased by J.N. Wolf. In 1884, Wolf sold it to Virge Long. For the next twenty years, several different families lived in the house for short periods until it was finally purchased by A.E. "Gene" Holton. In 1909, Holton bought the house and the two-acre "Joyce Lot" from J.M. Hinshaw and his wife for $1,200. The lot adjoined the Yadkinville Presbyterian Church and a roller mill.

FAMOUS HOLTON FAMILY

Quentin Holton was a pro-Union, Methodist preacher who was as familiar with the classics and mythology as he was the Bible. Quentin moved his family of seven children from Guilford County to Yadkinville. The entire Holton family, both men and women, were well educated and socially prominent.

Rufus Holton, the oldest son of Quentin Holton, married Elizabeth Shields and, later, Miss Ellen Thomasson. Rufus owned and operated the Jesse Dobbins Mill. He was elected clerk of the Yadkin County Court in 1890 and again in 1894 and also ran a mercantile store in Yadkinville. His oldest son, A. Eugene Holton, a banker, later purchased the house. He and his wife, the former Bessie Nicholson, had two daughters: Mable and Marjorie. The girls grew up, married and each had two children.

A.E. Holton made substantial changes to the Joyce House. The one-story back wing of the house is believed to be the original tavern part of the building. The two-story part is believed to have been built in the 1880s.

Holton had the entire house turned around so that it faced north instead of east. He also added a wraparound porch with Tuscan columns and a connecting balustrade that curves around the northeast corner of the porch. The original windows were replaced with two-over-two, double-hung sash windows.

After the deaths of A.E. Holton and his wife, the house passed to their daughter, Marjorie Holton Prim, and then to her husband. It was rented to various families. For about ten years, the house was filled with antiques and curios owned by Mrs. Lou Todd Hutchens. When Mrs. Hutchens went out of business, the Yadkin Arts Council leased the building as an art gallery/craft shop. Recently, the house again has been rented as a home.

TRAGEDIES ASSOCIATED WITH THE HOUSE

According to the Yadkin County, North Carolina marriage register, William A. Joyce married Mary "Mollie" Wilson on August 15,

The Joyce-Holton-Prim House, one of the earliest taverns in Yadkinville.

1861. Mollie died shortly after giving birth to their daughter, Percie (born in 1864, died in 1944). William A. Joyce died in 1867.

Mrs. Sarah Joyce lost the house because of a lawsuit brought by relatives of her daughter-in-law, Mollie Wilson Joyce, on behalf of Mollie's orphan daughter, Percie Joyce. Sarah was forced to live with her daughter Wilmuth, the widow of Dr. York.

Born in 1801, Sarah Stone Joyce died at age ninety-eight in 1899. A Quaker, Sarah is buried at Deep Creek Friends Church north of Yadkinville.

Robert H. Joyce served as a sergeant in Company I, Twenty-eighth Regiment, North Carolina Infantry. He was killed near Petersburg on June 22, 1864. A.R. Joyce was a private in the same company as his brother. He was wounded at Chancellorsville in May 1863 and again at Gettysburg in July 1863. A.R. recovered from his wounds and was still with the Army of Northern Virginia when Robert E. Lee surrendered at Appomattox Court House on April 9, 1865.

Although he did not die in the house, Dr. Lewis York, the son-in-law of Mrs. Sarah Joyce, froze to death during the bitter cold winter of 1893 while on his way to visit a patient.

MURDER AND SUICIDE

According to the late Mrs. Estelle Vestal Johnson Gough (1879–1967), a man who lived in the Joyce-Holton-Prim House shot and killed his daughter's suitor on the stair steps. Since it is believed that the two-story addition only dates back to the 1880s, the murder must have involved one of the families who lived in the house between 1881, when Mrs. Joyce lost it, and before 1909, when A.E. Holton bought it.

Another tragic death occurred in the house when a woman, who was very ill with typhoid fever, became delirious and jumped out of an upstairs window. The fall broke her neck and she died. The woman may have been a student or a teacher at the Yadkinville Normal School run by Professor Zeno Dixon in the late 1800s. The window has since been boarded over so that no trace of it remains.

A MYSTERIOUS EVENT ON HALLOWEEN

Descendants of the Holton family say they have never heard that the house was haunted, but at least one unusual event occurred there just a few years ago.

Danny Casstevens, my very artistic and musically talented oldest son, was scheduled to have a showing of his art in the Joyce-Holton-Prim House in November 2005 while it served as the gallery of the Yadkin Arts Council. On October 31, 2005, Danny took a stack of framed paintings and drawings to put on display in the old two-story house. Kathy Titus, the curator, admitted him. On the first floor, Kathy and Danny walked into the room on the left, turned on the lights and looked around. Then Kathy walked to the room on the right and turned on the lights. When she did, the lights in the room on the left went out.

Naturally, Kathy, having seen how Lisa Douglas (Eva Gabor) coped with this sort of electrical problem on the TV show *Green Acres*, went into the kitchen and unplugged the refrigerator to cut down on the amount of electricity being used. When she unplugged the refrigerator, all the lights in the house went out.

Was there simply a problem with the electrical wiring? Common sense would suggest that there was some sort of electrical overload. Or was there a spirit making its presence known?

Who can answer that question? Strange things have been known to happen, especially on Halloween in old houses where untimely deaths by murder or suicide have occurred.

HOUSE HAUNTED BY THE SPIRIT OF AN INDIAN

A friend of mine, who wishes to remain anonymous, told me this story, which occurred in his own house. He shall be referred to as Mr. Brown in the following story.

In prehistoric times, many tribes of Indians lived in the shadow of Pilot Mountain, near the Yadkin River in what is now Yadkin County. For centuries, Indians moved across the area in search of wild game. Some of them lived along the banks of the river and creeks. Evidence that the Indians inhabited the area can still be found almost everywhere. The river bottom land is littered with arrowheads and bits of broken pottery made by the Indians. Indian burial sites in the river bottoms near Donnaha have been excavated by archaeologists from Wake Forest University. Some say that the strange mounds found in other areas of the county are also Indians graves.

A new housing development was built off Union Cross Church Road in Yadkin County. Undoubtedly, no environmental impact study was done, or else the houses here would not have been built right on top of ground sacred to the Indians.

After Brown's lot was graded in preparation for construction of his new house, many arrowheads and other objects that had clearly belonged to Indians were uncovered. He picked them up, and after the house was finished, he kept his finds in a box in his new house.

Brown and his wife had not been living in their new house very long when they began to hear strange noises. The sound of someone walking heavily on the second floor could be heard, yet there was no one there. The sound of drawers being opened in the bathroom was frequently heard, as if someone was searching the house. When they searched for an intruder, there never was anyone in the house except for Brown, his wife and their little dog.

Many times Brown heard the outside storm door open, and then he heard the front door open. The storm door had a chain that always jiggled when it was opened. The sound was unmistakable. One day, Brown heard the storm door open and thought that his wife had come home from work. However, when he looked at the clock, he saw that it was far too early for her to be home. When he searched the house, she was not there. Who had opened the door?

One night the couple was sitting in their living room watching television when their little dog looked up toward the ceiling and began to bark frantically, as if he saw some approaching danger. The couple sensed it too. Finally, in desperation, Mr. Brown spoke to the unseen visitor: "I am a God-fearing, tax-paying man. I mind my own business and expect others to leave me alone. If you are a spirit of the Indians who lived here, and you are upset because I took the arrowheads, I will put them back where I found them. I promise that I will never dig anything up again, and I will see that my family does the same, if you will go and leave us in peace."

Suddenly, the presence seemed to disappear and the little dog settled down and went back to sleep in the man's lap. Since that day, there have been no more mysterious sounds or doors opening by themselves. The Indian ghost must have been satisfied and decided to leave the family in peace.

COINCIDENCE OR FATE

One day Richard and his wife Elaine traveled from Yadkin County to visit an apple orchard near Spruce Pine, North Carolina, just off the Blue Ridge Parkway. There they met John, the owner, who told them an interesting story about how he had acquired the orchard.

John had purchased a home and settled in Little Switzerland after retiring from a career with IBM. His sister, Ann, obtained a real estate license and began selling real estate in that fast-growing region in Cary and near the state capital at Raleigh. John's sister usually drove up to the mountains on weekends to visit him. However, one week she came on a Wednesday, and she happened to see a copy of the local Spruce Pine newspaper. Ann began to read the paper's "for sale" advertisements and saw that an apple orchard and a large tract of land on the Parkway was for sale. The price of the tract was very reasonable, compared to what land with a house was selling for in Cary.

After talking together, the brother and sister agreed to call the Florida number listed in the advertisement. The owner of the property usually let his answering machine take calls. However, when John and Ann called, the owner picked up the telephone to talk to them.

They offered the owner the asking price for the property and gave their promise to continue to operate the apple orchard. The man in Florida accepted their offer. Very shortly, Ann faxed the necessary papers to the owner. Once the legal work was completed, the transaction was closed quickly.

No sooner had John and Ann acquired their orchard than they were approached by a man who wanted to buy part of it. As a developer, he offered a tempting bargain for just a small parcel of land that had no apple trees on it but was near the Parkway. His

offer exceeded their total investment. John and Ann declined his offer, although they were tempted to accept it.

John moved into the house and began operating his new orchard. One day, a group of reenactors marched down the old road that ran through the orchard. John approached them to find out what was going on. He learned that the men were recreating the march of Colonel John Sevier and a group of men down the old road from Tennessee across the Blue Ridge Mountains into North Carolina. Near the North Carolina–South Carolina line, Sevier's men and other Patriot forces defeated the British and Tory forces on October 7, 1780, in what is now known as the Battle of Kings Mountain.

John learned that the reenactors called themselves the Overmountain Men. Their story sparked John's interest and he and his wife drove down to the Kings Mountain Battlefield to learn more of its history. He was told that the Patriots were successful because their strategy of attack had prevented the British from using their bayonets. While at the battlefield, John tossed a rock on the grave of Major Ferguson, who had lost his life there.

The Battle of Kings Mountain was a turning point in the American Revolution. The Loyalists were led by Major Patrick Ferguson, the only regular British officer at that battle. He was the son of a Scottish judge and had joined the army at age fifteen. He was well known for his marksmanship and had invented the breechloading rifle. After obtaining a patent on the rifle, he organized an elite rifle corps that was sent to America to serve under Sir Henry Clinton. The young Scotsman was well liked by his men, and he was noted for his good disposition. He was slight of build but was quite handsome. A courageous fighter, Ferguson had participated in several battles in the 1760s.

After the British invaded North Carolina, the Patriots were determined to drive them out. A group gathered at Sycamore Shoals on the Watauga River in Tennessee. Led by Colonels Charles McDowell, John Sevier, Isaac Shelby and William Campbell, hundreds of men followed them through the snow-covered mountains to Quaker Meadows Plantation near Morganton. There they were joined by other Patriots from Wilkes County, led by Benjamin Cleveland and Joseph Winston. The

combined force of about nine hundred men set out to find the British and defeat them.

Major Ferguson advised Lord Cornwallis of the impending attack and requested reinforcements, which never came. Major Ferguson and his Tories were camped on the summit of Kings Mountain. He believed he was safe there because the summit was too steep for the enemy to scale. Ferguson was wrong.

The Patriots surrounded the mountain and began the assault. They were skilled hunters who could fire their rifles with great accuracy.

In order to be heard over the noise of battle, Major Ferguson issued commands to his men by the use of a silver whistle. Dressed in a checkered hunting shirt worn over his uniform and blowing his whistle, Ferguson was a "sitting duck." He was hit by a bullet. As he fell, one foot caught in the stirrup, and he was dragged, with his foot still in the saddle, to the side of the Patriot forces. His last act was to shoot the Patriot who asked him to surrender. Some accounts say that he was hit by as many as eight bullets. Other accounts say that the British major was carried to the shade of a tree, where he died shortly thereafter.

The battle ended in a decisive victory for the Patriots.

After John returned to his home in the mountains, his aunt came to visit. He told her the story of the Overmountain Men and of his trip to Kings Mountain. The aunt laughed and said, "Now I know why you bought the orchard and why you went to Kings Mountain, and why you threw the stone on Ferguson's grave."

John looked at his aunt in amazement. "Why?" he asked his aunt.

The aunt then filled him in on his family history. His ancestor, several great-grandfathers back, had been one of the Overmountain Men. John's ancestor, although he was over fifty years old, and a young boy had been assigned to look after the Patriots' horses. Suddenly, the young boy spotted Major Ferguson making an attempt to escape on his horse. John's ancestor, who already had his musket loaded and ready to fire, took aim, fired and hit Ferguson. The British general was knocked from his horse. Although this account does not quite agree with the historical account, it did give John a

sense of pride to know that his ancestor had been involved in the battle and may have been the one who shot Major Ferguson.

John's aunt concluded that some strange forces must be at work to enable her nephew and his sister to purchase this particular property. She did not know if John's ancestor had owned the orchard property, but she was sure that he must have marched across it on his way to the battle.

Was it just coincidence that Ann traveled to Spruce Pine on Wednesday when she usually came on weekends? Was it a coincidence that John and Ann were the first to get through to the owner about purchasing the orchard? Or was it fate that the Overmountain Men marched through John's newly acquired orchard? Was it fate that John went to Kings Mountain and found the grave of Major Patrick Ferguson? Was it fate or coincidence that John told his aunt of his visit and that she knew of their ancestor's actions there? Could John's ancestor have been the one who fired the fatal shot at Major Ferguson?

Whether truth or fiction, John learned about the battle at Kings Mountain and that his ancestor may have played an important role in one of the turning points of history.

GHOST OF COLONEL LANIER STILL HAUNTS THE SHALLOW FORD

The area along the Yadkin River, especially in the vicinity of Huntsville, is thinly populated. Along the banks of the muddy river, there are many acres of dense forest where only wild animals roam. It is an almost mystical place, forgotten by time, a world where ghosts and the spirits of the departed still live. Once, armies fought near the Shallow Ford. Along the Great Philadelphia Wagon Road and the Mulberry Fields Road, skirmishes occurred between Patriots and Tories, and later Yankees and Confederates. Today, only the spirits of those men remain.

As a young man was delivering a pizza, he drove down the dusty road across Dinkins' Bottoms. He crossed the one-lane bridge over Deep Creek and continued south toward the Courtney-Huntsville Road, a trip he had made many times without incident.

The delivery boy glanced to his right and then quickly looked again. He saw what appeared to be a transparent figure of a man in a Revolutionary War uniform astride a large horse charging toward him down the little hill known locally as Hickory Ridge. The pizza delivery boy almost stopped his car but decided he did not want to clash with anyone, either a crazy man or a ghostly apparition. So he sped up and soon was across the river bottom.

The boy was still shaken when he rang the doorbell of the house where he was to deliver the pizza. He told the lady of the house what he had seen, and she shook her head in disbelief.

"Maybe you've been working too hard," she told the boy. "Are you getting enough sleep?"

"Yes, ma'am," the boy replied. He pocketed the money she paid him and continued on his way. He did not return the way he had come but instead continued along the paved highway where there were houses every few yards.

Was the boy imaging things? Or did he really see the ghost of a soldier from the Revolutionary War? Had it been the ghost of Colonel Robert Lanier?

British general Lord Cornwallis had come through the area in February 1781 as he chased American general Nathanael Greene. Cornwallis learned that Lanier was an active Whig and that he lived nearby at the Shallow Ford Plantation, just across the Yadkin River in what is now Forsyth County. (The Lanier House would later belong to Captain Thomas Poindexter, who married Lanier's widow, and eventually pass to R.C. Puryear, a member of the Confederate legislature during the War Between the States.)

Failing to capture Greene, Cornwallis decided to take his frustrations out on Colonel Lanier. However, Lanier saw the British troops descending the steep hill to cross the river at the Shallow Ford. Knowing the area well, Lanier moved his men northward on the east bank, crossed the river at a bend above the Shallow Ford and reached the opposite bank just above the mouth of Deep Creek. (This is now called Dinkins' Bottoms, the same area where the pizza boy allegedly saw the apparition.)

Lanier remained hidden in a damp, swampy canebrake all night while the British general and his troops spent the night in Lanier's home. The next day, after looting Lanier's home, the British marched toward the Moravian town of Salem. They were followed by a Patriot force led by General Sumter.

There is another version of the events that occurred when Cornwallis crossed the Yadkin River. This version has been handed down in the Jarratt family. According to Jarratt family history, when the American Revolution began, Robert Lanier got a company of men together and they joined General Nathanael Greene's army. Colonel Lanier's wife made him a new uniform.

Lanier sent his body servant to his home ahead of Cornwallis's approaching army to get his new uniform. The servant was to meet Lanier downriver at the Trading Ford, where General Greene crossed the river. When Cornwallis arrived at the river, he decided to wait until morning to cross. When morning came, the river was up and the lowlands were flooded. Cornwallis had to march along

The broad river bottom land, as seen from the yard of the Conrad-Dinkins House.

the west bank of the Yadkin River to search for a safe place to cross. This gave Greene time to escape.

Lanier's body servant reached his home, picked up the uniform and started back with it. He crossed the river at the Shallow Ford and traveled down the west side to meet his master. Instead, he met the British. The servant decided to put on the uniform and travel along with the British. He had no idea that Cornwallis would cross at the Shallow Ford and head for the Lanier place.

When Cornwallis rode up to the house with the servant by his side, the woman of the house, Jane Pattillo Lanier, was furious when she saw the black servant wearing his master's new uniform. Her account, handed down in the family, states that "she forgot she [was] a lady and also that she was the daughter of a straight-laced Scotch Parson, and without even speaking to Gen. Cornwallis, she proceeded to drag the negro from his horse and taking his riding crop, made him strip to the waist and gave him a good thrashing and also a very proficient string of profanity along with each stroke

of the whip," while the British general looked on with amusement and a broad smile on his face.

Colonel Robert Lanier escaped being captured by Lord Cornwallis, but he died of an unknown cause sometime after 1781 but before May 26, 1786, when his widow, Jane Pattillo Lanier, married Captain Thomas Poindexter.

So, if the pizza delivery boy did see an apparition, it may not have been Colonel Lanier but his body servant riding across the river bottom to escape the wrath of Mrs. Lanier. Perhaps the poor slave is still angry because he was whipped for doing the best he could in a bad situation.

Update: Since this story was first written, the dirt road across Dinkins' Bottoms has been elevated and paved and a new two-lane bridge has been built across Deep Creek. In the process, many Indian artifacts were discovered.

THE GHOSTLY WOODSMAN

When Roy was a child in the 1950s, he and his parents often visited his grandparents. Their home was in an area north of Highway 67 on what is now called Tower Road, which begins across the highway from the former restaurant known as Howard's Grill.

Many times Roy heard a strange sound that occurred near the home of his grandparents. At the same time each day, the sound of a tree falling to the ground somewhere in the woods could be heard. From near his grandparents' house, the sound seemed to come from the ridge south of the house. However, if he was standing on that ridge, the sound seemed to come from the area near the house.

Many times those who heard the sound searched the woods, but the results were always negative—no recently fallen tree was ever found. No one ever heard any sounds to indicate that someone was chopping down a tree. It was always just the loud, unmistakable sound of the tree as it crashed to the ground.

The origin of the sound of a tree falling remains a mystery until this day. Was the sound an echo across time from the distant past?

MYSTERIOUS LIGHTS

At one time, a Mr. Adams lived in Yadkin County near the north end of Forbush Road where it turns off the Nebo Road. His house was on the right side of the road, about two hundred yards from a dangerous curve in the road.

While living there, Adams often saw a mysterious, glowing light. The light would move from within the woods about three feet above the ground. It would cut across his front yard and then reenter the woods. The strange light always followed the same path.

If anyone attempted to approach the light, it would disappear. If anyone shined a flashlight at the light, the mysterious light went out.

Adams never learned the source of this strange light. The ghostly light did not come from automobile headlights. It did not come from a lantern or a flashlight carried by hunters, and it was not generated by foxfire or swamp gas, as there were no swamps in the area.

The appearance of this light raises many questions. Did the light cross the road to warn motorists about the dangers that lay ahead along the narrow, curvy road? Had someone been killed in an automobile wreck at the curve in the road and the spirit of that person remained to haunt the area?

Or was the light simply some unknown and mysterious natural phenomenon?

THE GHOST OF VESTAL'S MILL

The following account is an edited version of a true story written by the late Mary Williams Richie about something that happened to her and her brothers when they were children.

An ancient building called Vestal's Mill once stood in fading but lofty dignity on South Deep Creek some three miles southwest of Yadkinville. The murky creek water bubbled over bedrock and was scooped up by the wheel that powered the millstones. The dam above and the washout below the falls provided the only swimming hole within easy reach of families from a wide area.

In the days before running water and municipal or private swimming pools, the water near Vestal's Mill was famous as a good place for children to swim on a hot summer day. On weekends and holidays, local people, adults and children turned out en masse to picnic on the huge rocky outcrop between the creek and the mill building. Children laughed and splashed water on one another. Some pretended they were water nymphs in the cool, refreshing water of the creek. The slide down the moss-covered rocks below the dam was better than any found in modern water parks, and it cost nothing.

By night, the shaded bank of the creek was a favorite trysting place for love-smitten couples.

For one Yadkinville family, summer came and was gone too quickly. On a warm Sunday afternoon late in September, the three Williams children begged their father to take them to Vestal's Mill as he arose from the dinner table.

"Please take us, Papa. Soon it will be too cold to go swimming. But the weather is perfect today," begged Mary, the youngest of the three. Their father usually gave in to his children's wishes, but today he was annoyed. He had other plans. "It is too late in the season to

go swimming," he said. "I doubt if there will be other adults there to help in case one of you gets into trouble."

"Please, Papa, we won't get into any trouble. Please take us just this last time," Joe chimed in. "I'll watch the other two, if you'll just take us there."

Mary chimed in, "Uncle Burton will be there. He's always in the mill doing something or other."

When they continued to beg, Mr. Williams stated other obstacles to the outing. "I believe a storm is coming up." When the threat of a storm did not stop their pleas, he told his children, "And besides, I have to go to Wilkesboro and will not be back until after six o'clock."

"That's perfect," Lafayette, the middle child, beamed. "You can drop us off as you go up, and we will meet you back at the road and you can pick us up and take us home."

Mr. Williams gave up. Although he was a good attorney and could present an argument in court well enough to gain the release of a suspected murderer, he had no such luck with his children. Logic did not faze them. They persisted in their pleas, wore down his last defense and usually got their way.

By one o'clock, the three youngsters were on their way to the creek. Their father let them out at the road, with the understanding that they were to walk a quarter of a mile from the highway to the mill and to be back at the highway by six o'clock to meet their father. The children had often gone to the creek. The water was not deep and usually there were other people there. If not, they knew that Uncle Burton would be there to keep an eye on them.

At fifteen, Joe, the oldest boy, was to be in charge of Lafayette, age twelve, and Mary, age ten. He was an excellent swimmer. Joe set an alarm clock to go off at 5:30. He tucked the clock under his arm and started down the road toward the cool water.

Since it was a warm day, the children stopped long enough to remove their shoes and walk barefooted. As they walked down the dirt road, they began to play "Daniel Boone," one of their favorite outdoor games. Walking in single file, the leader sought the soft sandy spots in which to leave his footprint. Those behind were to follow his tracks or any other tracks they decided on, such as those of a wagon or a horse.

Joe looked at the road and then at his brother and sister. Then he said, "I don't believe there's been anyone over this road since it rained." Mary and Lafayette agreed. It had not rained since late Friday afternoon.

He began to think out loud: "Uncle Burton must be here. He could not have gone anywhere without leaving tracks in the road." Uncle Burton was no relation to these children but was called that by everyone who knew him. He had lived in a small house near the gristmill he had operated for more years than anyone could remember.

"Good, then more than likely he is at home," added the younger brother Lafayette hopefully. Actually, none of the children wanted to be entirely alone. What if they saw a snake, or something worse?

Joe changed the subject. "I'll race both of you to the mill. I'll even give Lafayette and you a head start," he winked at Mary. "Lafayette can get as far as the walnut tree and you to the plum tree before I even start."

Lafayette balked. An advanced position didn't particularly appeal to his sense of honor, and he said no.

"Then we'll all start together and the first to reach that persimmon tree by the side of the road wins," said Joe. He began reciting the standard starting chant: "Rickenbacker, Rickenbacker, Studebaker, Bee. Here we go—one, two three."

As expected, Joe, being the biggest and the oldest, won the race easily. Unexpectedly, Mary came in second, and Lafayette brought up the rear.

Once the three had reached the persimmon tree, they paused to look toward the creek. The sun was hiding behind a small, puffy cloud and the laurel on the distant hill looked black and foreboding. There were no tire tracks, hoofmarks or footprints around the mill to indicate recent visitors to the mill.

The children walked in silence for another hundred yards until they were in sight of Uncle Burton's house. Joe called out, "Hello!"

There was no answer. He continued to call until they reached the front door of the miller's house and realized that no one was there.

"Maybe he's inside the mill," suggested practical Lafayette. The three children looked at the mill. It appeared taller and older then usual. The windows high up on the side of the building looked like eyes watching their every movement. They walked cautiously past the front door and saw that it stood ajar. Joe walked up on the porch of the mill, peered in the open door and called for the miller. When he received no answer, he turned his attention to the creek.

Joe challenged, "The last one in is a rotten egg," a dare that could not be ignored.

Mary pleaded, "You have to let me change first." The boys paid no attention to her. They deposited their dry clothes on the bank of the creek, changed into an old pair of pants and were already in the water by the time their sister changed from her good Sunday clothes into her "swimming clothes." In the early years of the twentieth century, a swimming outfit consisted of a blouse and a pair of serge bloomers.

Sketch of Vestal's Mill. *Courtesy of artist Caren Casstevens.*

Joe and Lafayette took turns ducking and baptizing each other. When Mary finally jumped in, the water was surprisingly cold. They grabbed her and dunked her about five times in a row. She squealed with laughter. Then Lafayette and Mary grabbed Joe and held him under until he made a circle with his foot, which was a signal of surrender. Laughing, the children climbed up and sat on a submersed rock and let the full force of the creek wash over them. They waded downstream and climbed up the bank to get a drink of cool, fresh water from the tiny spring.

While they were thus occupied, the sun disappeared and black thunderclouds hovered close to the ground. As the children started running upstream, a thunderclap released a tremendous torrent of rain. The three could hardly see their way back to the rock where they had left their clothes. Bolts of lightning spurred them on, and at last they retrieved their clothes and the alarm clock.

"Run to the mill porch," Mary suggested. The porch faced away from the creek. When they reached the porch, each drew a sigh of relief. Not daring to go inside the mill, the three crouched against the wall near the half-open door. No one spoke as the rain fell harder. Lightning flashed, coming closer and closer, and thunder rolled around them.

Suddenly, with a terrifying clang, the alarm clock went off, and simultaneously, the children were aware of someone or something moving inside the mill. The three children bolted headlong into the pouring rain. Some fifty yards away, Joe thought of their clothes and looked back. He tried to speak, but no words would come. He pointed at a second-story window, and the other two turned to look.

Even through the rain, an apparition glared down at them. The children stared dumbfounded at the figure that peered out at them from a window high above. What they saw made them forget everything—lightning and thunder, rain, clothes and alarm clock. The sinister face that peered at them had long, stringy snow-white hair. Below its dark and melancholy eyes hung a long, white beard that covered most of its face.

Joe at last found his voice enough to say, "Look! It has horns!"

Mary did not care to verify her brother's statement. She got her second wind and headed up the hill. Joe and Lafayette followed,

but this was one race in which their sister led all the way. The trio did not stop until they reached the highway. They stood shivering in the rain to wait for their father.

They paused briefly to debate whether to await their father or start for home. It was still raining hard. The three finally decided it was best to put as much distance as possible between them and the haunted mill. They started running west along Highway 421 toward Wilkesboro. That way, they would not miss their father.

They had not gone very far when Mr. Williams saw them and stopped. The shivering, soaked, speechless children quickly climbed in the warmth and safety of the automobile.

"Where are your dry clothes?" the father asked.

"On the porch at the mill," was the only reply any of them could muster.

The children's father stopped at the road that led to the mill. "Now, tell me," he demanded, "what this is all about. Why did you meet me without the rest of your clothes?"

Joe attempted to tell his father. "The door was open, and we heard someone in the mill and we ran. When we looked back, we saw something scary."

"Just what did you see?"

Mary explained, "We saw a white face with great big eyes and a long white beard looking out of the window on the top floor and…"

"And it had horns, too," Joe added.

Mary continued, "I didn't see the horns, but I didn't look as long as Joe."

Lafayette chimed in, "The mill door was open and the alarm clock went off, and…and a ghost ran up the steps and…"

"We ran away," the three said in unison.

Their father was skeptical, but he was also practical. He did not want the children to leave their clothes, and he did not like their statement that the door to the mill was open. He turned the car down the road to the mill.

The three children were silent all the way. There was another downpour of rain as they approached the miller's house. Mr. Williams looked at the mill. The front door was still open, as the children had said, but he saw no face in the window.

He drove the car a little closer and stopped. He got out of the car in a heavy rain and retrieved the children's clothes from the porch. He returned to the car and said nothing as they drove home. On the way and ever after, those three children believed that the face that peered out at them from the window could not possibly have been human. It was gaunt, bearded and snowy white. The dark and melancholy eyes seemed to project great sadness.

To no avail, Mr. Williams tried to convince his children that what they had seen in the window was simply a mass of spider webs. After years grinding wheat into flour and corn into cornmeal, everything in the mill, including spider webs, was covered with a coat of white dust that had accumulated. He even suggested that perhaps Uncle Burton had played a trick on them. The children were not convinced. They knew they had seen a ghost.

Sometimes the children had nightmares about a man being caught beneath the massive grindstones to die an agonizing death. The three children concluded that someone undoubtedly had met such a gruesome death and that his spirit haunted the mill.

Update: Sadly, in the 1940s, the mill burned down. Filled with grain, it burned for hours. Volunteer firemen from all over the county worked to contain the huge fire.

People still go to the creek on hot summer days to swim in the cool water and sun on the warm rocks.

A SOLDIER'S PREMONITION AND MENTAL TELEPATHY

The late Bertha (Hinshaw) Mackie often told this story to her grandson. Like all mothers of sons who are away in service of their country, Bertha was constantly worried about the safety of her three sons, all of whom were in the armed forces.

Her oldest son, Howard Lee Mackie (1919–1944), was drafted into the United States Army during World War II. A neighbor, lifelong friend and fellow soldier, Ford Dixon, served with Howard Mackie in the army and was near him when he was killed. Ford recalled that before their units were shipped to France, he and Howard were eating a meal in London. Howard confided to Ford that he never expected to see his home in Yadkinville again. Ford replied, "If I thought that, I would go home right now!" Howard was correct. Did he have psychic powers or the ability to see into the future? This ability has been called ESP (extrasensory perception) or "second sight." Many Celtic descendants, such as the Scots and Irish, are known to have this ability.

On the night of June 23, 1944, Mrs. Mackie awoke from a sound sleep in the middle of the night. She knew instantly that her son Howard was dead. In a couple of days, she was notified that Howard had been killed near Cherbourg, France, on June 23, 1944. Had Mrs. Mackie experienced "mental telepathy"? Was her son Howard able to communicate with her as he was dying?

In 1951, the remains of Howard Mackie were returned to Yadkinville and buried in the family plot at Harmony Grove Friends Meeting. Howard was a birthright Quaker and a member of that meeting.

SKELETON IN THE DOORWAY

An elderly woman related an unusual experience. When she was a young girl, she lived with her family in the Quaker Deep Creek section of Yadkin County. One evening, her mother received the sad news that an elderly cousin was dying. Her mother wanted to visit the dying relative one more time. She decided to take her daughter with her on the visit.

After they had changed into their Sunday best, mother and daughter began walking down the unpaved road to the sick woman's home, which was nearby. Along they way, they passed a vacant house. When the daughter turned to look at the house, she gasped. She saw a skeleton standing inside the open front door. The bones of what was once a human were bleached white and devoid of any flesh or clothing. The head had empty sockets where its eyes had once been, and the lower jaw gaped open as if to emit a scream. With its arms bowed out, the skeleton's elbows touched the inside of the door frame as if to hold itself up. The legs of the skeleton were bowed out in that same position, with the knees touching the frame of the door.

The daughter tugged on her mother's hand and asked in a whisper, "Mama, did you see that skeleton in the doorway?"

The mother did not stop, nor did she look toward the empty house. She whispered to her daughter, "Don't look back. Just keep on walking."

Years later, the daughter wondered if the skeleton in the doorway was Mr. Death, because their sick relative died that same day. She also wondered if her mother had seen the skeleton and chose to ignore the specter because she knew it was a harbinger of death. Or was it just a deception of light and shadows that played tricks on the eyes of a little girl?

NOISES IN THE "TEACHERAGE"

George "Podgy" Helton was casually talking to another teacher one day. They shared some of their teaching experiences. Early in his teaching career, Podgy taught in the public school at Snow Camp, North Carolina. Being single, he rented a room in the local boardinghouse for teachers, nicknamed the "teacherage." Podgy arrived early in order to get a room on the first floor of the boardinghouse.

One night, Podgy could not get to sleep because of strange noises coming from upstairs. No other boarders had arrived yet to take up residence, so the second floor of the house was empty. Yet the noises continued. In desperation, the young teacher shouted, "Shut up! I'm trying to get to sleep."

Suddenly, the noises stopped, and Podgy went to sleep. The young teacher never did discover who or what had been making the noises in an upstairs room that was supposed to be empty.

THE GHOSTLY PRESENCE

Andrew Mackie does not believe in ghosts, but he has encountered things for which there seem to be no rational explanation. For several years, Andrew has lived in the house that once belonged to his grandparents, Jesse (died 1975) and Bertha Hinshaw Mackie (died 1977). The house, on West Main Street in Yadkinville, is a framed, one-story house with a wide front porch. It was built about 1916, in the days when a woman's home was her "castle."

Everyone in town knew that the house was Mrs. Mackie's pride and joy and she always kept the house in good repair. Typical of the times, a framed house painted white with green window shutters indicated that the woman of the house took pride in the appearance of her home.

A couple of years ago, Andrew entered his home through the back door, and proceeded to the front bedroom, where he kept his computer. As he entered the room and turned on the overhead light, he felt a "presence." He did not feel threatened by it, but he was puzzled and did not understand what it was or why it was there.

This happened several times, and Andrew decided to try a mantra that his psychic second cousin had taught him. He said the words, "If you be of God and love, then you may stay. If not, please leave!" The mantra failed to banish the unwelcome presence. The presence remained and followed Andrew from room to room.

Andrew began to worry. He called his friends and family to see if everyone was all right. Everyone said that they were fine. In all the years he had lived in the house, nothing like this had ever happened before. The "presence" remained and continued to plague Andrew.

One day, he mentioned the unusual feeling he had of something or someone being in the house to his friend and neighbor, Jim

Grant. Jim, who had a fine sense of humor and always loved to tell a good joke, said seriously, "Andrew, maybe your grandmother is trying to tell you that your house needs painting."

Andrew looked at Jim in amazement. Perhaps he was right. He had put off having the house painted for some time. Black mildew had begun to grow on the white boards. So he hired a paint crew to remove the mildew and apply a new coat of white paint. To Andrew's amazement, after the house was painted, he did not feel the strange "presence" anymore, and he expressed his gratitude. "Thank you, Grandmother."

Andrew never discovered who or what had invaded his house, but whatever it was, the presence never returned after he had the house painted. Perhaps it was the spirit of his grandmother who wanted her house kept in good repair to set an example for the neighbors, and convey to them how much she still loved her home.

A GHOSTLY PLAYMATE

The following story was told to me in a telephone conversation by Laurie's mother. The following events are true, as she believes them to be.

Laurie's parents finally were financially able to buy a home near East Bend. The house was about sixty years old. It was probably built in the late 1950s. The family was happy to have their own home and not have to pay rent. With a little paint, it would be as good as new.

However, Laurie's parents had no idea that the house had unseen occupants. This became apparent when many strange and unexplainable things happened, both inside and outside the house. Strange things continued to happen even after her death. Even today, Laurie's mother says sometimes it feels like someone is in the house watching her when she knows that she is alone. Doors open by themselves and objects fly around the room.

The first indication that there was something unusual going on was when Laurie's mother came home from work one afternoon and could not find her daughter. She searched the house and called repeatedly, "Laurie, where are you?"

When she received no answer, the mother went outside to search for her beautiful, blonde-haired child. She found ten-year-old Laurie crouched behind the shrubbery on the north side of the house.

Laurie's blue eyes lit up when she saw her mother, and she ran to her.

"Why were you hiding, Laurie?" her mother asked.

Laurie looked up at her mother, but at first she could not speak. She was shaking as if she had a chill. Her mother picked her up and carried her back into the house. Consoled by her mother's presence, Laurie finally stopped shaking, and she told her mother what had happened.

"Mama, please don't be mad at me. I was sitting in the living room watching cartoons on the TV. I didn't hear the door open or any noise. But, suddenly, a little girl in a white dress just appeared and sat down beside me. I turned to her and asked her name but she didn't answer me. Her image grew dimmer but she did not completely fade away, and I could still feel her presence."

Laurie's mother did not know what to make of the story. Her daughter was not prone to making up stories.

"Was that why you were outside?" she asked.

"Yes. I was frightened and I ran outside to get away from the little girl."

Undoubtedly, the apparition had frightened Laurie badly. Laurie's mother was puzzled by her daughter's story, but she soon forgot all about it.

As Laurie grew older, she did not mention the little girl in white to her parents, but she told her girlfriends about the strange little girl who often visited her. Laurie confided to one of her closest friends that sometimes the ghost would climb into her bed. This frightened Laurie so much that she began to sleep with a light on in her bedroom.

Laurie's mother forgot all about the ghostly visitor, but occasionally she would hear a conversation between two people coming from her daughter's room. When she would open the door to Laurie's room, there would be no one there except her daughter, so she assumed she was just talking to herself.

As time went on, Laurie grew older and the ghost grew bolder. After she got her driver's license, Laurie mentioned to her friends that the little girl had begun to accompany her when she went places in her car. The ghostly figure rode on the passenger's side. This began to occur more frequently during the last few weeks of Laurie's life.

Laurie was killed in Davidson County in an automobile wreck on January 26, 2005. She was only eighteen years old. At the scene of the accident, an unknown man walked up to one of the nurses with the rescue team and asked, "Can I do anything to help?" He was told that she was "already gone." When the nurse looked back, the man had disappeared.

After her death, the family had Laurie cremated and kept her ashes in the house. Strange things continued to happen. Laurie's mother had put a picture of her daughter inside a cabinet. One morning, she was surprised to find the picture sitting on the kitchen table. No one knew how it got there. A picture that had been hanging over the refrigerator suddenly flew off the wall and landed near where Laurie's parents were sitting at the kitchen table.

Another time, Laurie's gloves were found on top of the television. Twice, Laurie's father thought he saw her walking through the house. Were these occurrences imagined, or was Laurie trying to communicate with her parents from the other side?

At Christmas, Laurie's mother was taking pictures. A cat appeared in one of them. This was very strange because there was no cat in the house. When she looked through her photograph album, Laurie's mother saw that many of the pictures she had taken in the house had small white spots, the type that ghost hunters call "orbs."

Why was Laurie haunted by the ghostly presence of a little girl? Was she afraid of the little girl in white, or had she become used to her presence over the years? Was the little girl a good spirit or an evil one? Was the little girl Laurie's guardian angel who failed in her task to guard Laurie from danger?

If the ghostly little girl was riding with Laurie when the accident occurred, did her presence distract Laurie and cause her to pull out in front of a large truck? Was she the harbinger of death? Or was the pale little passenger sent to guide Laurie into heaven? We will never know the answer to these questions.

THE WIDOW COULD NOT SLEEP

The following three stories were shared by Cynthia Sue Brewbaker Royall.

Sue's grandparents lived in the ancient house in the old village of Huntsville now called the Chapman-Brewbaker House. Local tradition holds that the house was built in the late eighteenth or early nineteenth century. The one-story-plus-loft house sits on lot 15 of the original plat of the town of Huntsville. The little house appears similar to some of the old houses in the Moravian towns of Forsyth County.

The house sits on High Street between a blacksmith shop and a livery stable. This quaint old house has been occupied for at least two hundred years. Its walls are steeped with memories of its many occupants and of those who passed by the house in the days when Huntsville was a thriving, busy village. During the mid-1800s, the house was occupied by Allen Chapman and his daughter, Mary.

Stoneman's Federal cavalry marched past this house on its way to Salisbury to release prisoners held there. Fortunately, the soldiers did not stop to burn this house as they had the Red Store at the northern end of the street. A local legend says that the attic of the Chapman-Brewbaker House was once filled with trunks full of Confederate money. The money has since disappeared.

Several of the Brewbaker boys who lived in Huntsville joined the Confederate army. Alexander, one of the brothers, received a letter from his girlfriend, Mary Chapman, pleading with him to come home. She mentioned that there was to be a corn shucking. Alexander's longing to see his sweetheart got the best of him, and he deserted. The Home Guard found him and hanged him for desertion. Miss Mary blamed herself for Alexander's death because she had begged him to come home. Her grief lasted the rest of her life. She never married, but she did will this house to Alexander's

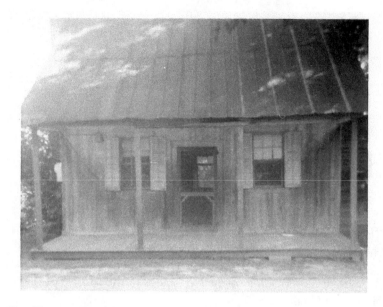

The Chapman-Brewbaker House on High Street in Huntsville with clapboard exterior. This was later the home of Miss Mary Chapman, who served as the Huntsville postmistress.

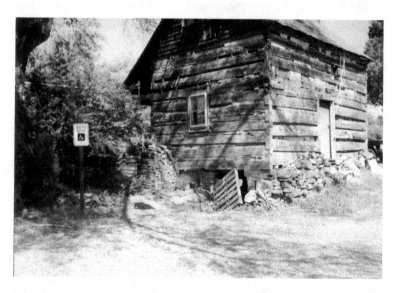

Built about 1800 by Allen Chapman, recent renovations to the Chapman-Brewbaker House show the original log construction.

great-nephew, Paul Brewbaker, because he looked so much like his unfortunate relative, Mary's beloved Alexander.

After Miss Chapman's death, Sue's grandfather, Paul Brewbaker, and his family moved in. He lived there until his death in 1982. For a few years, his widow continued to live alone in the house. After her husband's death, when Mrs. Brewbaker went to bed each night, she heard a voice calling her.

"Mer," the voice called repeatedly every night for a week. (Mer was the pet name her husband had always called her, although her name was Eva.) The widow could not get any sleep because of the voice.

Finally, Mrs. Brewbaker sat up in her iron bed, turned on the lamp and said, "Paul, if you got something to say to me, say it and get done with it, so that I can get some sleep." After that, she was not bothered by the voice again.

Today, the clapboards have been removed to expose the original log construction. After extensive remodeling, the old house is now open as a gift shop.

MINISTERING ANGELS OR IMAGINARY VISITORS

As a child, Sue was very sick with strep throat and she had a high fever. Alone in her bedroom, she awoke one night to the sound of people talking. She opened her eyes and saw three people in her room standing beside her bed. She could clearly see a man, a young girl and a little girl. The young girl, who appeared to be about sixteen, started to touch her as she said, "We've got to help her."

"Don't touch her," the man said and grabbed her arm before it could touch the sick child. That frightened Sue and she began screaming. Her parents heard her screams and came running into the room. Her mother placed a hand on her forehead and could tell immediately that she was burning up with fever. Without waiting any longer, her parents took her to the hospital.

When she recovered, the girl asked her parents about the three people who had been in her room. Her mother just smiled and said, "Honey, you just imagined you saw some people. It was because you had such a high fever." Her mother did not believe her daughter's story.

"But, Mama, I know what I saw and heard," the girl repeated. Her mother just shook her head and smiled. The girl's grandmother was the only person in the family who believed her.

Years later, that little girl grew up and began to research her family history. One day she saw a picture of Ruby Brewbaker, whom she remembered as one of the strange visitors when she had been sick. She began to dig deeper into her family history. She discovered that the old house in which she and her parents lived when she was a child had previously been the home of her great-grandparents, Thomas Dyon Brewbaker and his wife Emma Blanche, and their brood of nine children. One of the children of Thomas, Columbus "Lum" Brewbaker, was one of those three people she remembered seeing when she was so sick.

Lum was prone to drink more than he should, and he was found dead in the house one day in 1954. Sue also learned that Lum's sister Ruby had a tooth pulled in 1918 when she was sixteen and had died from infection. Sue discovered that the third visitor, a little girl, was Lum's sister, little Flo Ella. The girl had been badly burned and had died in 1911 when she was just three years old.

All three of these long-dead people who appeared to Sue were siblings of Sue's grandfather Paul, and all three had died in the old house where Sue grew up. She was certain that it was the long-dead family members who had been watching over her and that they had been concerned about her when she was very ill.

Whether it was a dream or a vision, when Sue cried out, her mother, who had already retired for the night, came into her room to check on her daughter. If her mother had not come, Sue's temperature might have reached an irreversible level that could have caused her to have seizures or resulted in brain damage or even death.

Sue never forgot the three visitors who were in her room that night. She knew who they were, and she was comforted by knowing her relatives had been watching over her.

UNEARTHLY CRY CAME FROM THE OLD CEMETERY

Sue and her friend Sharon liked to ride their bicycles on the deserted roads around Huntsville. One day, Sue and Sharon rode down a narrow dirt road to where it forked. They stopped and parked their bikes because the road was too overgrown with weeds to ride safely. The girls decided to walk down the right fork of the road to the deserted old Mount Sinai Cemetery.

A Methodist church had been established near the cemetery in 1808. Typical of churches of that era, there was a raised pulpit for the minister and an upstairs gallery for the slaves to sit in so that they could attend services. The church was used until a new church was built in 1888 on the main road on the edge of the village of Huntsville.

Unused, the original church soon disintegrated. This left only the old cemetery to mark the site of the earlier church. As the old families died out and the dead were buried in the cemetery of the new church, the old cemetery was abandoned to the elements and was seldom visited by anyone. Brush and brambles, even small trees, grew among the old headstones, and a carpet of leaves covered some of them entirely. Here and there sunken places were the only evidence of where bodies had been buried, because they had been interred so many years ago that even the headstones and footstones had disappeared. The old Mount Sinai Cemetery was not a place one would visit in the dead of night. However, on a bright, sunny Sunday afternoon, with little else to do, the girls decided to amuse themselves by visiting the old burying grounds. When they reached the cemetery, the girls were amazed that there were still some tombstones standing. Many of the inscriptions on the lichen-covered tombstones testified to just how long ago some of these graves had been dug to hold the wooden caskets of the dead.

In 1888, the Huntsville Methodist Episcopal Church replaced the old Mount Sinai Church.

As the girls wandered around looking at the inscriptions, the afternoon sun slowly dipped behind the tall trees and dark shadows lengthened across the graveyard. The two friends drifted apart and became separated. Suddenly, they both heard a noise. Sue thought that Sharon was making a noise to scare her, and Sharon thought the same of Sue. It was a weird noise, like nothing they had ever heard before. It seemed to be coming from the woods past the cemetery. Sue said softly, "Sharon, was that you making that noise?"

In the late twentieth century, no one believed that there were any bobcats in Yadkin County until this one was run over by a car and killed in the 1960s. It was given to my father, Boone Harding, who had it mounted.

Sharon moved closer to her friend. "No, I thought it was you."

It was an eerie sound, like that of some animal in pain. The girls had heard stories that panthers and bobcats still inhabited the dense forests near the Shallow Ford. Mount Sinai Church was deep in the woods, not far from the ford. Although these animals were never seen, Huntsville residents often reported hearing the cries of panthers echoing through the woods and across the hills that bordered the river. When someone ran over a bobcat with a car on the Shacktown Road, the rumor that bobcats continued to inhabit the area was confirmed.

Sue was frightened. "Maybe it was a just a bobcat," she said. Bobcats were much smaller than panthers but still wild and dangerous creatures.

The sound came again. To Sue, the cry sounded almost like the last sound a hanged man would make before the rope tightened on his neck and he was strangled to death. One of Sue's ancestors

had been hanged by the Home Guard during the Civil War. He probably had been buried in this old cemetery beside his parents, his brothers and other relatives.

The frightened girls looked at each other, and without uttering a word, they ran as fast as they could for home. They did not even stop for their bicycles. Sue's mother had to return with them later to retrieve their bikes.

The girls never knew what made the strange noise. On a practical level, they decided the sound could have come from a moonshiner who had a still in the woods and wanted to frighten the girls away. Or it could have come from a wild animal caught in a trap. Or it could have been the tortured spirit of a hanged man or someone else who was buried in the old, abandoned cemetery.

Sue still gets an eerie feeling whenever she visits the old, abandoned cemetery, and to be on the safe side, she never goes there alone.

Update: In recent years, coyotes have also been reintroduced to Yadkin County and other areas they had once inhabited. They sometimes kill poultry and other farm animals, and even household pets.

THE HAUNTED PLANTATION

Morgan Bryan was one of the first settlers in the Yadkin River Valley. He acquired 510 acres on the south side of Deep Creek from Lord Granville in 1752. (See Rowan County, North Carolina Deed Book 1.) Bryan was the grandfather of Rebecca Bryan, the wife of the famous hunter, Indian fighter and scout Daniel Boone. The bottomlands of the river and its many tributaries were filled with wildlife and, according to legend, were a favorite hunting ground of Daniel Boone.

Bryan did not keep the property very long but deeded it to his son, Thomas Bryan(t) Jr., in 1758 (Rowan County Deed Book 2). Nearly ten years later, Thomas deeded the land to John Kimbrough (Rowan County Deed Book 7).

On this large tract of land was once a graveyard that contained tombstones that marked the graves of Lydia Howell and her husband, Thomas. The inscription on Lydia's grave noted that she died on November 4, 1777. This small cemetery has since been desecrated and the old tombstones removed. The Howells must have owned the land at some point, or were related to someone who did.

The land was sold several times, and the plantation came into the possession of Larkin Lynch (Linch). The Lynch family had lived in the Surry-Yadkin area since before 1779. In 1850, Lynch listed 532 acres on Logan Creek. Since the Bryan land was described as being on South Deep Creek, Lynch must have purchased it after 1850. This tract of land became known as the Larkin Lynch Plantation.

By 1860, Larkin Lynch was wealthy. He was listed that year as a "negro [slave] trader" with real estate valued at $16,000 and personal property (including slaves) valued at $54,550. The Lynch plantation had cabins that were the homes of countless slaves before 1865. After 1865, tenants lived in those same cabins, some of them probably former slaves.

Lynch and his wife, together with their six children, lived in a two-story house that faced south toward the old Mulberry Fields Road. The antebellum house known today as the Larkin Lynch House resembled Glenwood, home of Tyre Glen, because of its hip roof. It was two stories high and had two rooms that opened onto a center hall. The house was surrounded by a picket fence. The Lynch House also had a large two-story ell in the back.

The plantation was self-sufficient. A blacksmith shop provided tools and equipment, and a store stocked goods needed by the family, the slaves and the surrounding neighbors.

A short distance behind the main house, Harmon Creek and South Deep Creek converge. The plantation was situated between those two creeks. The extensive creek bottoms provided good crops from the fertile ground. It was rumored that no one minded working in the bottomlands during the daytime, but most of the workers were afraid to go there during the night because of the strange lights that were often seen floating across the fields. It was said that the lights were the souls of those who had died violent deaths on the plantation.

The place where the two creeks met was also feared because of the very real danger of drowning. After a heavy rain, the water in the creeks always rose to a dangerous level. A traveler was wise to wait until the water level receded before attempting to cross. Several strangers who did not know of the strong currents that could sweep a man and a horse away had attempted to cross and were drowned.

The story of the bridegroom who failed to attend his wedding is one of the most tragic events that occurred on the Lynch Plantation. He was to be married, and his bride awaited him across the creek at the Lynch Plantation. By the day of the wedding, rain had fallen steadily for three days, and the waters of the creek were raging. The guests had arrived at the house. The fiddle player hired to furnish the wedding music fiddled and fiddled, but still no groom appeared.

The bride was in tears. Surely her true love would come. He would not jilt her on her wedding day. The bride and her parents, along with the wedding guests, waited until darkness fell, but still

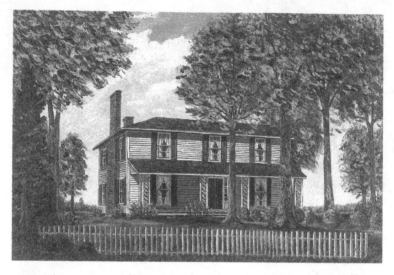

Oil painting of the Larkin Lynch Plantation. *Courtesy of artist Danny Casstevens.*

the bridegroom did not come. Some of the guests spent the night at the plantation, hoping that the groom would arrive the next day. However, the next day brought only bad news.

The bride was still awaiting her true love when news came that his body had been found several miles downstream. In his efforts to avoid missing his wedding, the young man had attempted to cross the treacherous, swollen stream and was swept away and drowned.

A large cedar tree stood at the edge of the drive that led to the house. Many of the people who have visited there tell of seeing a light that seems to glow from inside the branches of that cedar tree. Some say that the light in the cedar tree is a beacon to guide the bridegroom to his wedding.

After the Civil War ended, the Lynch Plantation changed hands several times until it was purchased by Attorney S. Carter Williams. Williams moved his family there before buying a house in Yadkinville. While living in the beautiful old house, one of the Williams girls recalled the noises that could be heard in the attic over the kitchen. The noises sounded like chains being dragged

across the floor. She believed that slaves had once been chained there and that their agony had echoed through the years.

Williams owned the place when the flood of 1916 engulfed the house. For several days, the house, which sat on a rise, appeared to be on a small island in a sea of muddy water.

Unfortunately, this stately house burned about 1935 and was never rebuilt. It has been brought back to life through the artistic talents of Danny Casstevens. With the aid of photographs of the house made in 1914 and firsthand descriptions furnished by the late Mary Williams Ritchie, Danny created an oil painting of the house. Color prints, twenty by twenty-seven inches, of the Larkin Lynch House are available for about twenty-five dollars from the Yadkin County Historical Society, PO Box 1250, Yadkinville, North Carolina. Notecards and envelopes are also available.

WIND CHIMES GET RID OF GHOSTS

In a northern Piedmont county stands a large, two-story, Victorian-style house. The house once belonged to a family who loved their home and kept it in pristine condition. When the parents died, the children moved away to work in larger cities.

Mrs. Smith inherited the house, but she did not want to live in it. She did not want to sell the house, so to keep it from standing vacant, she rented it. Unfortunately, the house was frequently vacant because the renters did not remain very long. Instead, they sometimes left very suddenly, claiming that the house was "haunted." Many of the occupants told the owner that they often saw the ghost of a little old lady. The ghost was small, not over five feet tall. When she appeared, the tiny lady ghost was usually cleaning or tidying up the house. She was seen sweeping the kitchen floor at night. A young lady who lived in the house reportedly was brushing her long hair when she saw the reflection of an elderly woman in her bedroom mirror.

Generally, the little ghost was harmless, and the occupants of the house were not afraid of her. At other times, the apparition seemed angry and sometimes pulled books from the bookshelves or knocked tubes of makeup from the counter in the bathroom.

One day, Mrs. Smith told a friend that the present renters had moved out of her house because they believed that the house was haunted. Mrs. Smith's friend had an answer to her problem. She said, "Ghosts don't like wind chimes. Why don't you hang some wind chimes in the kitchen window, or wherever the ghost is seen most often?"

"Thanks," Mrs. Smith said. "It won't hurt anything to try it, and just maybe it will get rid of any restless spirits."

The next day, Mrs. Smith bought some wind chimes. The chimes made a beautiful, tinkling sound that was soothing to the ears. She

hung the chimes in the kitchen. That night, the ghost came to the kitchen and threw the chimes across the room.

Since the house was unoccupied at the time, there was no account of what occurred that night. However, Mrs. Smith did note that the next family who occupied the house stayed for several years, and not once did they complain about unexplained visitors or strange noises. The chimes may have proved effective in ridding the house of its resident ghost.

THE DEATH OF JESSE DOBBINS

Jesse Dobbins was born in Yadkin County, North Carolina, but he did not support the Confederate cause. A member of the Friends Church (Quaker), Jesse had been hauling salt for the Confederacy when he received word that he had been drafted.

As the war progressed, the Confederate Congress enacted a draft law to replenish its troops. Jesse and several other men planned to flee across the mountains to safety behind Union lines to avoid the draft. He and fifteen other men were waiting inside the Bond Schoolhouse for the weather to improve. Someone reported their presence, and Captain James West and a group of state militia arrived to take Jesse and the others into custody.

West banged on the schoolhouse door and demanded their surrender. The door opened and West received a gunshot wound to the head. Gunshots from both sides followed, and West and one other militiaman were killed. Two of the draft dodgers in the schoolhouse were killed, and the rest, led by Jesse Dobbins, fled across the mountains to the Union lines. Jesse joined the Union army and drove a wagon for the Union for the remainder of the war.

After the war was over, Jesse returned to Yadkin County with money in his pocket to settle down with his wife and family. He built a large, two-story house that stood beside Country Club Road until just a few years ago. He engaged in various commercial enterprises. He dammed a small stream to create a lake (now known as Dobbins Mill Pond) and built a gristmill. He prospered financially.

Abraham Lincoln was not on the ballot in North Carolina in 1860 and 1864, because there was no Republican Party in this state. Dobbins sought to remedy that situation, and he, together with three other prominent citizens, established the Republican Party in Yadkin County. That did not sit well with the hundreds

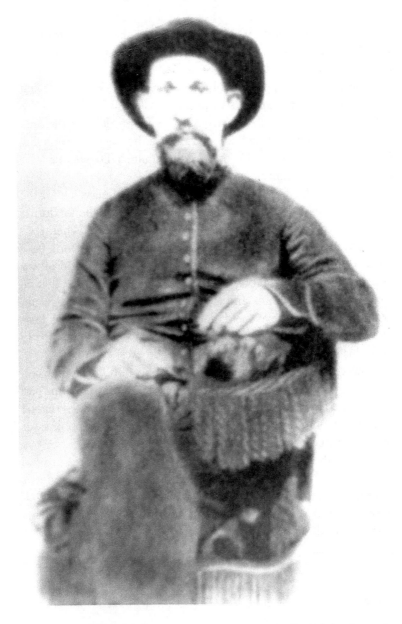

Jesse Dobbins fled the county after the shootout at the Bond Schoolhouse in February 1863 to serve as a Union soldier. After the war, he prospered from several business enterprises. *Courtesy of the Yadkin County Historical Society.*

of Confederate veterans who had returned to the county from the war. Those veterans also harbored ill feelings toward Jesse because he had fought for the Union.

Some people saw Jesse Dobbins as a hero who stood up for what he believed was right; others viewed him as a traitor to the South and a murderer as well. When Jesse was found dead at his mill, rumors circulated that he had been killed either by an unforgiving Confederate veteran or by one of the staunch Democrats who remained in the county.

Some said that if Dobbins had been killed, he deserved it for the part he had played in the shootout at the Bond Schoolhouse during the war. Some believed that he had shot Captain West. When Jesse returned to Yadkinville in 1865, the sheriff tried to arrest him. Jesse escaped and rode to Salisbury. He returned with a federal officer and a contingent of Union soldiers. The officer demanded that all charges against Dobbins and the others be dropped. As a result, no murder trial was ever held, and the guilt or innocence of Jesse Dobbins was never determined. Jesse never got his day in court to prove his innocence in the death of Captain West.

However, an examination of the application for a pension submitted by the widow of Jesse Dobbins stated that Dobbins had been treated by Dr. E.M. Allred for some time. Allred stated that he believed Dobbins had died suddenly of a stroke. Jesse Dobbins was only fifty-three years old at the time of his death.

Perhaps the ghost of Jesse Dobbins does haunt the area around Dobbins Mill Pond. Maybe he cannot rest until his name is cleared of the murder charge. Of the many strange things that have occurred at Dobbins Mill Pond, as is shown in the following stories, not all of them can be attributed to the restless spirit of Jesse Dobbins.

THE HAUNTED MILLPOND

What locals call Dobbins Mill Pond is actually a small lake just a couple of miles north of Yadkinville. In days gone by, it was a popular place for fishing, swimming or simply parking and making out. The man-made lake was created by building a dam across a little creek to provide a source of water for a gristmill operated at one time by Jesse Dobbins. The "pond" contained the usual variety of fish, frogs and snakes. Snakes could sometimes be seen eating the frogs.

The deep and murky water of the lake hid other things. Stolen automobiles had been driven into the depths of the lake. A stolen safe was also believed to have been dumped into the dark waters. And there were always stories about people who had drowned and their bodies never recovered from the silt on the bottom of the lake.

AN UNUSUALLY COLD WINTER

The lake has a tragic history. In February 1940, the surface of the lake had been frozen solid for several days. The ice was seven inches thick. It was so solid that it did not crack even when an automobile was driven onto the ice several feet away from the bank. Skating parties were organized and couples skimmed merrily across the frozen surface. A winter this cold, with lakes frozen enough to skate on, had not occurred in this area in many years. The frozen lake was a novelty that attracted people from a wide area.

Water accumulated under the ice and could not flow normally out into the small creek. Finally, the buildup of pressure broke the earthen dam. It was a sight to see. When the dam burst, the pond was quickly emptied of water. Although no one was injured,

thousands of fish and other aquatic life perished. When the news of the dam break spread, hundreds of people came out in the cold to see what had happened and to capture some of the fish.

GOOD SWIMMER DROWNS

In the years just after the end of World War II, Yadkin County was still a backward, rural country. There were few paved roads and no public or private swimming pools. Many of the people who lived on the farms did not have indoor plumbing or running water. To get relief from the heat on a hot summer day, whole families would go down to a nearby creek so their children could wade in the shallow water. Those who wanted to swim had to go to a millpond, such as Dobbins Mill Pond (which was deep and dangerous in places).

Dobbins Mill Pond was a very popular place on Sunday afternoons, when there was little else to do in the county. Especially during the hot summer months, the pond was one of the most

Placid-looking Dobbins Mill Pond. The distance to the west bank is not far, but the water is deep and treacherous.

popular places in the county to swim, to fish from the shore or from a boat or just to enjoy watching others. It was easy to get to because a road wound around the bank and across the mill dam. There were plenty of places to park along the road to look out over the dark, rippling water of the pond.

June 1, 1947, was an unusually hot day for that time of year. After attending church and eating Sunday dinner, a young boy named Stanley Moxley and several of his friends decided to ride to Dobbins Mill Pond on their bicycles. They were hot after their ride and decided to cool off in the water of the pond.

The boys parked their bikes near where several small children were wading in the shallow waters on the east side of the pond next to the road. From there, the bottom gradually sloped off to a deep area that was many yards from the shallow part and about halfway to the west bank.

After the boys splashed around for a while, one of them issued a challenge: "Bet I can beat you to the other side."

"No, you can't beat me," replied Stanley. Somebody counted "1, 2, 3," and the boys were off in a deadly race across the dark water. For a while the boys were neck and neck, but then Stanley pulled ahead, determined to win the race. Although Stanley was a good swimmer, as he neared the far side of the lake, he suddenly disappeared under the water at a place that was at least twenty feet deep. After he went under that first time, Stanley never resurfaced. The other boys dived under the water to look for him but could not locate him in the murky depths.

When the news spread that a swimmer was in trouble in the pond, three men who had been fishing from a small boat rowed over to the spot where Stanley was last seen and began dragging the bottom of the lake with small hooks. Law enforcement officers arrived on the scene, and the sheriff requested that some prisoners be brought from the local prison camp to dive into the waters and search. The boy's body was finally located after over four hours of searching. He was an eighth-grade student who was to have graduated in just a few days.

Some people who were familiar with the waters of the pond believed that there was a cold streak in the middle near the west

bank that could cause a swimmer to experience cramps. Apparently that was what happened in this case, but no one knew for sure.

Local residents recalled seeing mysterious lights in the years following the drowning of the Moxley boy.

WATER-SKIER ALMOST KILLED

During the 1960s, someone built a ramp in the middle of the lake for the use of a newly formed water-skiing club. People came for miles around and parked along the banks of the pond to watch the boys glide across the lake on water skis. It was estimated that one summer afternoon, there were as many as two thousand people watching the activity on the lake. The crowd watched in awe as several small boats, powered by outboard motors, raced up and down the lake and pulled several young men on water skis behind them. The boats made great waves when they turned and started back toward the ramp.

Everyone was having great fun when an accident occurred. One of those on skis, Johnny Bell, either hit the ramp at the wrong angle or came down too soon. In the process, he fractured a vertebra in his neck. Fortunately, Bell was not paralyzed, and he recovered.

WHAT FRIGHTENED THE CAT?

In the 1950s, Dr. Hackett Harding and his wife, Blanche, were returning to their home in Elkin after a visit with Dr. Harding's mother in Yadkinville. Blanche had brought her beloved cat along. The cat, a huge Persian, had long, soft, white hair and big green eyes. She was appropriately named Mitzi Persian. She accompanied the Hardings everywhere.

Hackett loved to hunt and fish, and on their return trip he decided to take a detour around by Dobbins Mill Pond to see if the fishing was good on that hot summer day. The doctor and his wife were riding with the windows down (this was before automobiles had air conditioning). As they approached the pond, the water

glittered like millions of diamonds from the rays of the sun. The young doctor pulled off the road and parked his car near where some men were fishing.

Suddenly the cat, usually a docile creature, screeched and jumped out of the car through the open window. Mrs. Harding tried to catch her pet as she leaped out the window, but the animal was too fast. It was as if something had terrified the usually laid-back feline.

Blanche loved the beautiful cat and did not want to lose her. She could not understand what had caused the cat to suddenly jump out of the car and run away. The couple searched and called, "Mitzi, come here Mitzi." Normally, whether the cat was inside the house or out, Mitzi always came when her owners called her. But this time, the cat did not return. Sadly, as darkness approached, the doctor and his wife gave up the search and went on their way home. Over the next few weeks, every chance they got, Dr. and Mrs. Harding returned to the pond to search for the cat. They asked everyone who lived in the area if they had seen her, but no one had. Everyone promised to be on the lookout for the animal and to notify Dr. Harding if she was spotted. It seemed the big white cat had simply vanished.

Dr. and Mrs. Harding had no idea why the cat had jumped out of the car. She must have seen or heard something that her human owners could not. After weeks of searching, Mitzi Persian was never found either dead or alive. Perhaps the Persian cat sensed the ghost of Jesse Dobbins or the spirits of others who had lost their lives in the dark waters of Dobbins Mill Pond.

A CHILD DROWNS

Only four years after the death of Stanley Moxley, another tragedy occurred at Dobbins Mill Pond. Six-year-old Betty Colleen Cline did not know how dangerous water could be. Betty was with her father at the pond on a hot August day in 1951. He was busy washing his car and he did not notice that the child was missing until it was too late. Whether she got into water over her head or

whether she stepped in a hole in the shallow water was not known. After an hour, searchers found her body not far from the shore.

After the child's death, reports of the mist-shrouded figure of an angel hovering over the dark water of Dobbins Mill Pond began to circulate in the county.

Phillip Willard, former owner of Ace's Restaurant in Yadkinville, remembered that when he was a small boy, his father would take the whole family to Yadkinville every Saturday. There, his parents would buy their groceries and visit with friends while the children attended the movie theatre. It was usually late at night before Phillip's family started back home. Frequently, as the Willard family traveled along the road toward Dobbins Mill Pond, they could see strange lights dancing over the water. Phillip saw the lights, not once, but many times over the years.

The source of the mysterious lights was never discovered. The lights were not the reflection of the moon on the water because they still could be seen on moonless nights. The lights did not come from houses around the lake because, when Phillip was a small boy, there were no houses anywhere near the millpond.

Some people believed that the lights represent the spirits of those who had drowned in the millpond. Did the spirits of the dead haunt the millpond, or were the lights simply the result of a natural phenomenon, such as foxfire?

Still privately owned, Dobbins Mill Pond can be seen from Dobbins Mill Road, off Highway 601, north of Yadkinville.

THE OUIJA BOARD KNOWS WHO DID IT

Some strange events took place one night in the 1960s at my mother's home in Yadkinville. My father was in Raleigh attending a session of the state legislature and my mother was alone in the house. Her bedroom was upstairs. In those days, people in Yadkinville did not feel a need to keep their doors locked, for there was little crime.

The next morning when my mother went downstairs, she immediately noticed that something was not right. Someone or something must have entered her home during the night, apparently through the back door. She called and asked me to come up to her house. I lived next door with my family.

I was amazed at what I saw. In a trash can near that door, some blackened bits of paper were evidence that there had been a small fire. Not all of the papers in the trash can were burned, nor was the plastic trash can melted, so the fire must have been extinguished quickly. A trail of burned matches led from the back porch into the kitchen.

Nothing seemed out of order in the kitchen at first. However, we soon discovered that several items of clothing from the dirty clothes hamper had been crammed into the freezer compartment of the refrigerator. We found this very odd, to say the least.

In a downstairs bedroom, neatly folded and sorted articles of clothing had been jerked from the dresser drawers and thrown under the bed. Upon closer inspection of the room, we discovered that all of my mother's dresses in the closet had been shredded. They were cut from the bottom upward to the waist. Clearly, whoever did these things was deranged. I wondered what would have happened if Mother had been asleep in the downstairs bedroom. Would she have been slashed instead of her clothes?

These strange events scared me and my children, since they happened not long after the murder of Sharon Tate in California by the disciples of Charlie Manson.

From the evidence, it appeared that an intruder had entered the house, perhaps searching for money or other valuables that could be sold for drugs. Several weeks passed, and we learned nothing more about who had entered the house and done such dastardly deeds.

One of my children had a Ouija board. The square board is painted with letters, numbers, the words "Yes" and "No" and other symbols. On top of the board is the "planchette," a movable triangular object. When the fingers of the participants are placed on the planchette, it seems to move on its own to spell out the answer to a question.

According to some sources, something similar to the Ouija board was used in China around 1200 BC. Pythagoras and his sect are believed to have conducted séances at "a mystic table" that moved toward certain signs. Pythagoras interpreted the signs to the audience as being messages from an unseen world.

During the late 1800s, planchettes were sold widely as a novelty game. Elijah Bond and Charles Kennard obtained a patent in 1891 for a planchette that was sold with a board on which an alphabet was printed (United States Patent #446,054). It quickly became a very popular parlor game.

Many people scoff at the use of the Ouija board. Psychologists believe that the planchette moves because two or more people are touching it with at least one hand each, so that no single person need apply much force in order to cause it to move. Each person thinks that the planchette moves under its own power. Others believe that the boards can be used to make contact with the spirit world, but most believe that they are tools of the medium operating it.

Sylvia Plath's poem "Ouija" was influenced by experiments she and Ted Hughes made with the board. Her 1957 *Dialogue over a Ouija Board* incorporates the text of one of her sessions. Sylvia later committed suicide.

Pulitzer Prize–winning poet James Merrill used the Ouija board to receive messages from deceased persons. He combined

these messages with his own poetry in "The Changing of Light at Sandover," written in 1982. However, before he died, Merrill advised others never to use Ouija boards. Merrill had come to believe that it was dangerous to use the Ouija board because it could evoke evil spirits.

In order to learn who had entered my mother's house, my children urged me to ask the Ouija board. With much skepticism, I sat down with my children at our kitchen table. The oldest girl and boy placed their hands on the planchette, and I asked the question: "Who entered Mother's house and did those strange things?" I did not go into detail because if the Ouija board was genuine, it would know to what I was referring.

As the planchette moved around the board, I wrote down on a piece of paper each letter it indicated. Again and again, the planchette moved, paused at a letter and then moved again to letter after letter. Finally, it stopped moving entirely.

I looked at the paper where I had written down the letters. To our surprise, the message was not just a jumble of letters. The Ouija board had spelled out the answer to my question: "A hippie."

The answer given by the board confirmed our suspicions about what kind of intruder had been prowling in the house in the middle of the night. In the 1960s, the hippie movement was in full swing, and young men and women roamed the country, sometimes high on drugs and looking for money to buy more drugs.

That was one event in my life that I can never forget. Although we never learned the name of the intruder, the answer given by the Ouija board satisfied us at the time. Thereafter, when Mother was alone, she always locked her doors.

BRINGING MARY HOME

When my husband Jerry Casstevens and son Mike performed in their own bluegrass band, the Bluegrass Masters, one of their most requested songs was "Bringing Mary Home." This song had been recorded by the Country Gentlemen in 1972. Little did I know at the time that the words of the song were based on a true story that, according to one version, took place in Guilford County, North Carolina.

As the story goes, a young man was driving from Greensboro to his home in Lexington, and he passed through Jamestown in Guilford County. The road was curvy and the terrain hilly. At one point the road ran under a railroad overpass. The man knew the road well because he had traveled it many times. He always drove cautiously because there had been many wrecks on the curvy stretch of the road. That night, he was especially cautious because he kept driving through patches of dense fog along the way.

As he drove under the railroad overpass, he saw the figure of a woman standing beside the road. The woman motioned for him to stop, and he did.

When he pulled over, he saw that it was not a woman but a young girl dressed in a long white evening dress. He got out of the car and went around the back to the girl.

She looked very sad, and he asked, "Can I help you?"

The girl replied, "I want to go home. I live in High Point. Can you give me a ride?"

The young man was not about to leave a girl standing beside the highway late at night. "Sure," he said. "I'm going through there anyway." He opened the door of the car and she got in.

The girl looked at him and said softly, "I was at a dance, and as we were leaving, I quarreled with my boyfriend. I made him stop the car and I got out."

That's all she said until they reached the city of High Point. She pointed to a street and told him to turn right. "I live three houses from the corner."

Intent on watching the road and looking for her house, the young man stopped the car. He got out and went around to the passenger side to open the door for her. When he did, there was no one inside the car. He even looked in the backseat.

Puzzled as to what to do, he went up the walk to the house and knocked on the door. It was several moments before the door was opened. Apparently the residents of the house had already gone to bed.

An elderly woman opened the door and asked, "What is it? What do you want this time of night?"

The young man stammered, "I picked up a girl some miles back. She asked to be brought to this house. Have you seen her? Did she come inside?"

For a moment the old woman said nothing. Then she asked, "Where did you find her?"

The young man answered quickly, "At the Jamestown underpass."

"Ah, yes," the woman sighed. "It's always like this. You picked up my daughter Mary. She was killed in an automobile wreck thirteen years ago tonight. And each year since, on the anniversary of her death, she is seen standing by the road. Some young man always stops and picks her up and brings her to this house."

According to John Duffy's version of the song, the woman said, "You're the thirteenth one that's been here bringing Mary home." The old woman was on the verge of tears. "My daughter is still trying to get home, and I thank you for bringing her."

The young man stood speechless as the woman closed the door and went back into the house. Somehow, he made his way home. But he never forgot the young woman in the white evening dress standing beside the road, the woman who vanished from his car just as she arrived at her home.

Different versions of this same story are told in many states across the nation. The story is so prevalent that it has become an urban legend known as the "vanishing hitchhiker" story. The event

usually takes place on a dark and stormy night. A man picks up a woman standing by the road. They may or may not have any conversation, but by the time the car and its passenger arrive at her destination, she has disappeared. The man is left wondering if he has witnessed a ghost or if he has just been dreaming. Always, when he returns to the place where he left the girl, he is told that she has been dead for several years.

Another similar version of the story claims that the event happened in 1923 and gives the name of the girl in the white evening dress as Lydia. She was said to have been to a dance in Raleigh and needed desperately to get home. She gave a home address in High Point. This event is reported to have occurred on U.S. 70 near Jamestown, in Guilford County.

YADKIN COUNTY'S VANISHING HITCHHIKER

Yadkin County even has its own version of the story, according to author Michael Renegar. In his book *Roadside Revenants* (published in 2005), Michael tells the story of a girl named Mary who had been in an automobile accident sometime in the 1910s or 1920s. This event reportedly took place on a rural road in the western part of Yadkin County.

A man and his wife stopped and picked up a girl. It was a rainy night, and her ballroom gown was soaked and muddy. She told the couple that she had been in an accident, and she was frantic to get home to her mother. They agreed to take her home, and the girl got in the backseat of their car. When they reached the girl's home, she had vanished. In this version of the story, Mary's boyfriend was also killed, but his ghost has never been sighted. The tree that Mary's car struck is still standing and bears the scars it received in the collision.

According to Renegar's version, Mary has not appeared in several decades, not since her mother died. He suggests that she is no longer searching for her mother and is content now that she and her mother have been united by death.

HOOTENANNIE OR CHUPACABRA: CRYPTID OR URBAN LEGEND

R ecently, there have been several television programs about "cryptids." The term cryptid was coined in 1983 by John E. Wall to refer to a creature whose existence has been suggested but not confirmed by science. Cryptozoologists are encouraged by the fact that two creatures thought to be long extinct, the coelacanth and the okapi, have recently been found to still live. The Loch Ness monster of Scotland, lake monsters in Canada, the yeti of Tibet and the bigfoot, or sasquatch, recently sighted in many areas in the United States, all fall into the category of cryptids. Another mysterious creature that was reported on islands in the Caribbean, called a chupacabra (Spanish for "goat sucker"), has been added to the list of cryptids.

In the 1970s, tales circulated about the vampire of Moca, which was being blamed for the random killing of animals. Some believed that these deaths were the acts of members of a satanic cult. Others believed that the deaths were caused by some supernatural creature. However, more and more farmers began to report the deaths of their animals. In all cases, the dead animals had been drained of their blood through small, circular incisions on their necks.

The presence of the chupacabra was first reported in 1987 in Puerto Rico. Since then, it has reportedly killed animals in Mexico and the United States. The chupacabra supposedly attacks and drinks the blood of livestock, especially goats, of which there are many in the Caribbean islands and Mexico. The creature has even been blamed for the deaths of horses and other farm animals.

Tales of the chupacabra spread throughout the world. Sightings of the creature have been reported as far north as Maine and as far south as Chile. In April 2006, *MosNews* reported that the chupacabra had been spotted in Russia, where it reportedly had

killed thirty-two turkeys and drained their blood. Later reports indicated that thirty sheep had been killed the same way.

Some witnesses have described the chupacabra as being about the size of a small bear. It has a row of spines from its neck to the base of its tail. Others have reported that the creature can fly and has fiery red eyes. Witnesses report that it drinks the blood of its victims. It has even been described with batlike wings or as a lizardlike creature with leathery or scaly skin. It is reported to be about three to four feet tall, and it hops about like a kangaroo. Some have described it as having a dog- or pantherlike nose, a forked tongue and large fangs. Some reported that the creature leaves a sulfuric smell behind.

In Coleman, Texas, Reggie Lagow reportedly caught an animal that had been killing his chickens and turkeys. According to him, the creature was a cross between a hairless dog, a rat and a kangaroo. The body of this creature had been disposed of before any scientific examination could be made.

While many people scoff at the existence of such a creature, others claim to have seen it and witnessed the dead animals left behind, drained of all their blood.

Is this creature a figment of the imagination? Have witnesses exaggerated the reports of some animal such as a wild dog? Scientists are skeptical and believe this is just another urban legend.

Whether legend or not, reports of any unidentified creature strike fear in the hearts of those in the vicinity of where it has been sighted. Without any solid, physical evidence, the stories will continue and the creature will grow larger and more dangerous with each retelling. The stories soon become so exaggerated that they will evolve into legends.

The attention given to the chupacabra reminded me that in our own state there have been sightings of strange creatures reported to have killed small animals. People in Randolph County began reporting sightings of a large animal that was said to have killed livestock in 1969. Reports of the sightings were printed in the *Courier-Tribune* on January 21, 1969. The first newspaper article was titled "Mystery Animal Has Long Snout." This story stated that the county sheriff and game warden had been called to a farm

north of Franklinville to investigate the killing of a dozen hogs. The throats of the hogs had all been slashed by teeth so deeply that the animals were nearly decapitated. The hogs had been drained of all blood, but no flesh had been eaten. This is not typical of a predatory animal. A farmhand saw the creature, which he described as "black, slightly larger than a fox, with a tail like a fox and a long snout." (The "long snout" does not sound like any member of the cat family, such as a panther or cougar, but it might be a wolf or a wolverine.)

A second article that appeared in the January 24 issue claimed, "Mystery Animal Struck Again." A 175-pound hog was killed near New Hope. The sheriff reported that, again, the swine's blood had been sucked out by an unknown animal. A further examination revealed that the creature had jumped on the pig's back, bitten it and drank the blood until the pig dropped dead.

Another article that appeared on January 28, 1969, reported the killing of a calf on a farm between Randleman and Gray's Chapel. This time, the creature not only drank the blood but also had eaten some of the calf. Two weeks later, on February 13, the newspaper reported that the creature was believed to have moved on to Davidson County.

Soon, reports from residents in Forsyth County began to appear. The creature was believed to be a wolverine. Some people in the Piedmont area named the creature a "hootenannie" (or hootenanny). Why it was called "hootenannie" is unknown because that word is commonly used to describe some sort of unplanned musical event.

During the winter of 2004, the residents of several North Carolina counties were on the lookout for a strange beast that was roaming the country. There were many sightings of the creature. At first it was believed to be a large tiger, leopard or mountain lion that had escaped from the zoo at Asheboro. However, zoo officials denied that they had any of the big cats on the loose.

Rumors of a large catlike animal persisted. One fifth grader called the newspaper to report that a deputy sheriff had almost hit some large animal that ran in front of the car in which he was riding. Another student called to say that a black panther had been

spotted in the area and that zoo officials were tracking it with a tranquilizer gun. Both of these stories were probably false. Most people ignored these reports and said that these young people were just bored from being confined because of the ice and snow. "It's just cabin fever, people going crazy being confined for days because of the weather." However, once the weather cleared, reports of sightings continued. One young lady reportedly made a videotape of a large black animal eating something in her backyard. Again, zoo officials were called out.

During 2004, John Lutz, director for the Eastern Puma Research, received over one hundred calls from people who claimed to have sighted cougars in North Carolina. Although mountain lions (also called cougars and pumas) roamed the Piedmont centuries ago, in the twenty-first century, they are rare except in the Rocky Mountains. Could mountain lions still live in the Appalachian Mountains? Had the extreme winter weather driven some catlike animal from its lair in the Blue Ridge Mountains to the more populated Piedmont section of the state in search of food? The animal was never caught, and soon reports dwindled and then ceased.

Were the animals killed in North Carolina by a panther, a cougar, a bear or a wolverine? Or was it the chupacabra?

Update: On September 8–9, 2007, the CNN network program *News to Me* featured a strange creature that had been found on a farm near Cuaro, Texas. Three dog-like creatures were sighted after chickens had been killed and several kittens had disappeared. One of the creatures was hit by an automobile and killed. Photographs of the dead animal showed it had hairless, blue-colored skin and strange teeth.

Some believed the dead animal to be the legendary chupacabra. However, one scientist who was interviewed for the program was skeptical. He believed the creature was only a fox with a bad case of mange.

The animal shown on the program did not look very much like a fox.

GHOST AT BOSTIAN BRIDGE

In the 1890s, the best and fastest way to travel was by train. Not only were produce and livestock transported by rail, but there were also trains that operated solely for the convenience of passengers. One such train was Passenger Train No. 9, which left Statesville in Iredell County, North Carolina, on August 27, 1891, bound for the cooler climes and fresh mountain air that could be found in the area around Asheville.

One of the train employees was H.K. Linster, the baggage master. Linster was to retire after this last run, and he had just been given a gold watch by the railroad company for his many years of service. He was proud of that watch, and on that night he stood up and pulled it out of his vest pocket to check the time. He did not know it, but this would also be the last time that he would ever look at his watch. It was 3:00 a.m. and the train was speeding down the tracks southwest of Statesville. The train got about halfway across Bostian Bridge when it suddenly jumped off the tracks and plunged more than ninety feet to the ground below the bridge. Of the one hundred passengers, almost thirty were killed. H.K. Linster was among the dead.

A grandson of Mrs. Bostian, who owned the land where the train wreck occurred, believed that twenty-six or twenty-seven people were killed. Mrs. Bostian had lived in a white house on the hill near the bridge. The injured passengers were laid on the porch of her house until they could be treated. The dead were placed on the ground in the front yard. The accident made the national news, and people came from all around to view the site.

Exactly a year later, on August 27, 1892, people near the railroad tracks heard the sound of another train wreck. The sounds of the crash and then passengers crying for help were unmistakable. When several people went to investigate, they saw

only one man standing beside the tracks. He was dressed in the uniform of a railroad employee and holding a gold watch. He asked them for the time. The rescuers, thinking he must be in shock, did not answer him but climbed down the embankment to the crash scene. There was nothing there—no train, no injured passengers, nothing. They turned back to the man with the watch to question him, but he had vanished.

Since that time, the ghost of H.K. Linster and the train wreck have been seen repeatedly. It is believed that the train wreck is repeated on August 27 each year. The story continues to intrigue readers and authors. More information about the location of this bridge and photos can be found on several websites.

THE BROWN MOUNTAIN LIGHTS

The story of the Brown Mountain Lights has frequently appeared in books on folklore. It has puzzled scientists, historians, local residents and tourists for years. In the 1960s, when musician Tommy Faile was playing with Arthur Smith's band the Crackerjacks on a television station in Charlotte, North Carolina, he recorded a song about the lights that became a hit.

Brown Mountain is located in the foothills of the Blue Ridge Mountains in North Carolina, in the Pisgah National Forest. A good view of Brown Mountain and its mysterious lights can be seen from Wiseman's View on Linville Mountain. A sign on the Blue Ridge Parkway informs tourists that the long, even-crested mountain in the distance is Brown Mountain. The sign also describes the lights: "From early times people have observed weird, wavering lights rise above this mountain, then dwindle and fade away."

The mysterious lights have been described as a glowing ball of fire, a bursting rocket or a pure white light. Sometimes they drift slowly as they become brighter before fading away. At other times they look like pinwheels and disappear quickly. Sometimes they have a reddish color, at other times a blue tint. On dark nights, the lights appear so quickly and are so numerous that it is impossible to even count them. From Linville Mountain, the strange lights appear to be twice the size of a star as they rise over Brown Mountain.

The lights have been seen for centuries. They have become a part of Native American mythology. As far back as AD 1200, the Brown Mountain Lights were known to the Cherokee Indians. The Cherokee have a legend about a great battle that was fought that year between the Cherokee and the Catawba Indians near Brown Mountain. The Cherokee believed that the lights were the spirits of Indian maidens as they searched over the centuries for their dead husbands.

Some people believe that the lights are candles carried by ghosts doomed to walk back and forth across the mountains forever.

One of the legends about the origin of the lights is of a planter who traveled from the Piedmont to the mountains to hunt. He lost his way. When he did not return, one of his slaves was sent to look for him. The lights are believed to be the ghost of the slave as he carries a lantern in his endless searches for his master.

Another legend is that a woman was killed by her husband. Her friends and neighbors searched for her to no avail. One night a strange light appeared on Brown Mountain. The searchers believed it was the spirit of the woman that had come back to haunt her slayer. The search ended and many years later a skeleton was found under a cliff, which appeared to be the bones of the missing woman.

Geraud de Brahm, a German engineer, explored the region in 1771. He saw the lights and believed that the mountains emitted "nitrous vapors" that were carried by the wind to meet other vapors, and the impact caused them to burst into flames and then to deteriorate.

Some scientists speculate that the lights are the result of some atmospheric condition that reflects lights from the nearby towns of Hickory or Lenoir. However, the lights were reported to be seen before the War Between the States, when there was no electricity to illuminate these towns at night.

After the United States Geological Survey of 1913, scientists decided that the lights were a reflection of the locomotive of a train. However, in 1916, after a great flood swept down the mountains through the Catawba Valley, the railroad was destroyed and there was no train service for weeks. Roads were also washed out and power lines downed, yet the lights continued to appear during this time. This proved that the lights could not have been the result of train or automobile lights.

A second geological survey dismissed the lights as being the result of "spontaneous combustion of marsh gases." The only problem with this theory is that there are no marshy places anywhere around Brown Mountain.

The three best and most accessible locations from which to see the lights are: 1) Brown Mountain Overlook, 20 miles north of

Morganton, on NC Highway 181, 1 mile south of the Barkhouse Picnic area; 2) Wiseman's View Overlook, 5 miles south of the town of Linville Falls on Kistler Memorial Highway (Old NC 105 or State Road 1238); and 3) Lost Cove Cliffs Overlook at milepost 310 on the Blue Ridge Parkway, 2 miles north of the junction of the parkway and NC Highway 181. Please note that portions of the Blue Ridge Parkway are closed during the winter months.

UNINVITED BEDFELLOW

During the days of the witch hunts in the Middle Ages, women often testified that a demon known as an incubus had attacked them in the night. A man could be attacked by a succubus. A similar phenomenon was known as the "old hag." The victim of the "old hag" felt the presence of some entity lying heavily on top of him or her, making it difficult to breathe, and sometimes the victim thought that he or she was being strangled. William Shakespeare mentioned this belief in Act I, Scene 4 of *Romeo and Juliet*:

> *This is the hag, when maids lie on their backs,*
> *That presses them, and learns them first to bear,*
> *Making them women of good carriage.*

French novelist Guy de Maupassant described the experience, of which he seems to have had firsthand knowledge:

> *I sleep—for a while—two or three hours...then a nightmare seizes me in its grip, I know full well that I am lying down and that I am asleep...I sense it and I know it...and I am also aware that somebody is coming up to me, looking at me, running his fingers over me, climbing on to my bed, kneeling on my chest, taking me by the throat and squeezing...with all its might, trying to strangle me. I struggle, but I am tied down by that dreadful feeling of helplessness which paralyzes us in our dreams.*

Today, scientists and psychiatrists call this experience "sleep paralysis." They attribute it to the release of hormones during the period of REM (rapid eye movement). During that time, the sleeper's body is paralyzed. This is a safety measure that keeps the sleeper from acting out the dream. When the hormones dissipate,

the dream ends and the person awakes. The waking brain tries to rationalize the experience to account for the paralysis and the hallucinations that accompany it, which often take the form of demons, snakes, the old hag and even aliens.

In the last category, victims believe that they have been abducted by aliens from space and taken through walls to a spaceship where bizarre and painful examinations are carried out. Then, the sleeper is returned to his bed. Some of the people in this category have no memory of the event until it is recalled under hypnosis. Scientists are skeptical of alien abductions and believe that all such experiences can be attributed to sleep paralysis. Yet stories of alien abductions are frequently seen on television today.

My daughter bought a double-wide mobile home and had it set up on some land on a hill above the Yadkin River near the ancient village of Huntsville. She was just beginning to enjoy her new home when something strange began to happen. Sometimes, in the middle of the night, she was awakened when her bed started

The haunted double-wide home.

shaking. The shaking would continue for a minute or two. She would then get up and go outside to see if she could hear or see anything that could have caused the phenomenon. During the middle of the night, there was little traffic on the rural road, and she was several miles from Interstate 421. There were no reports of even minor earthquakes during this period.

This bed shaking continued almost nightly for a couple of months. Then, one night about 10:30 p.m., the familiar shaking ceased and she felt something lay down on the bed beside her. Then the thing turned so that it was sprawled out across her. The weight of the thing pressed down and she could not move. After a few minutes that seemed like hours, the weight lifted suddenly from her and from the bed. She neither heard nor saw anything or anyone in her bedroom. She never saw anyone or anything enter or leave her bedroom. Both the window and the door to her bedroom were closed.

The incident frightened her so much that she telephoned me to tell me about it. After hearing a familiar voice, she calmed down and finally went back to bed.

After that, the bed never shook again. No reason for the shaking of the bed or the force that was behind the unseen creature that lay down on her bed was ever discovered. It may just have been a case of sleep paralysis, or maybe it was something else entirely.

EXTRASENSORY PERCEPTION

Many people have had some sort of experience with extrasensory perception (ESP). The experience can be so common that the person may not be aware they are experiencing ESP. For example, I have a high school or college classmate who I have not seen or heard from in years who has since moved away. Suddenly, a picture of my friend pops into my mind. Then, the next time I am in the supermarket I see him or her, or I receive a letter from that person or read their obituary in the newspaper. That has happened to me many times. I have always attributed such events to coincidence. But was I really having an experience of ESP?

For about a year, every time the telephone rang, I knew who was calling. It was quite disconcerting, to say the least. Sometimes, family members are so in tune with one another that they seem to know one another's thoughts, even when they are miles apart. My two aunts, Joseline and Helen, claimed they knew what the other was thinking on many occasions. I had no brothers or sisters to practice this on, but I do have a daughter.

On a Sunday afternoon in 1993, I had been the hostess at the Charles Bruce Davis Museum of Art, History and Science, Inc., in Yadkinville. It was the last day of the exhibit of science fair projects created by Yadkin County elementary school students. My daughter Kay and her friend Selinda came by. We talked a while and I introduced them to my friend Bea Royall and her husband.

Near closing time, a woman and her children came to pick up her son's exhibit. After she left, I locked the doors and told my daughter to come by my house for a few minutes. She agreed. She backed out of the driveway in her car and I thought she was going to go directly to my home.

I followed her. We drove a couple of blocks and stopped at the intersection with Highway 601. For some strange reason, I suddenly

had the urge for a chocolate nut sundae. My daughter went straight through the intersection instead of turning right to go to my house. I did not follow her but went on home. I decided she must have needed to pick something up at the grocery store before coming to my house.

After I had been home for about five minutes, my daughter arrived. I walked out to meet her in the driveway. She was eating a chocolate nut sundae. "Hi, Mom," she said. "Would you like to have a sundae?"

Selinda got out of the car, walked around the rear to where I stood and handed me a cup. I looked down and saw the sundae I had envisioned on my way home. Kay had somehow read my mind and fulfilled my wish. I was speechless. A few days later, I mentioned this episode of ESP to my daughter. She remembered that when she stopped the car at the stoplight, she decided that she wanted a sundae. Either I picked up on her thoughts or she read mine. Was this a case of extrasensory perception at work?

GHOST OF THE MENDENHALL HOUSE

The following story took place in a Guilford County, North Carolina community called Jamestown. Journalist Bonnie Jordan noted in an article on ghosts that was in the June 26, 1978 issue of the *Greensboro Daily News* that any town with cobblestone streets "is bound to have a ghost or two, and Old Jamestown" is no exception.

COFFIN-TILDEN HOUSE

One of those haunted places in the Jamestown area is the Coffin-Tilden House. Levi Coffin, who lived in Guilford County before the Civil War, became famous for his work with the Underground Railroad. He moved to Indiana to continue the work of helping slaves escape to freedom in northern states and Canada.

A later occupant of this house recalled that her mother said that the sound of someone walking softly down the stairs could be heard when there was no one there. The sound was always of someone going down the stairs, never up.

MENDENHALL HOUSE GHOST

The house once occupied by James Mendenhall is believed to also have harbored a ghost. When a new family moved into the house, a ghostly image appeared. The man of the house was sitting outside in the yard when the image of a lady dressed in Quaker-style clothes came down the stairs, continued across the porch and on into the kitchen. She then came from the dining room and onto the porch again.

The man was so shaken that he went inside to get his gun and fired it several times at the misty image of a lady with gray hair, dressed in gray. The lady did not seem to notice that she had upset the man, and she continued to glide back up the stairs. The man decided he could not share his house with a ghost, so he moved his family to another house; he left behind only a few bullet holes in the walls of the house.

No stories about a ghost in the Mendenhall House have been heard recently, perhaps because it is now covered by the waters of High Point City Lake.

GHOST IN THE GOVERNOR'S MANSION

The first North Carolina governor's home, Tryon Palace, was completed in 1770 in New Bern. It served as the governmental center until the state capital was moved to Raleigh in 1792.

The first governor's house in Raleigh was a two-story frame building located at Fayetteville and Hargett Streets. It was soon replaced by the third state governor's residence at the foot of Fayetteville Street. This is now the site of Memorial Auditorium. A total of twenty governors lived here from the time the house was constructed in 1816 until 1865.

In 1865, Raleigh was occupied by Union soldiers, and the governor's mansion served as headquarters for General William T. Sherman. It later served the same role for the military commanders of the state during the Reconstruction era. Union generals and their soldiers left the house unfit for occupancy.

The present governor's residence was constructed because Governor Thomas J. Jarvis convinced the general assembly that it was needed. Once approval was obtained, construction began on a large building on Burke Street, just a short distance from the capitol building. Begun in 1883, it took eight years to complete the house. There was a constant struggle to find the money to complete the project, even though local materials such as clay, sandstone and timber were used and prisoners did the work at no cost to the state.

Once it was completed, the mansion has been continuously occupied by North Carolina governors. Governor Mike Easley is the twenty-seventh governor to occupy this mansion.

When Governor Kerr Scott occupied the mansion in 1970, there was a bed in the house that had been made for Governor Daniel Fowle in 1891. Fowle died in the bed only four months after taking office. Governor Scott decided he wanted a more modern bed, so

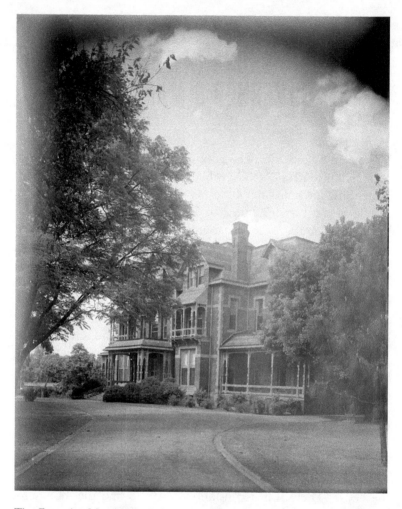

The Executive Mansion in Raleigh. *Courtesy of the North Carolina Department of Archives and History, Raleigh, North Carolina.*

he had the old bed moved to the third floor. The removal of the bed resulted in noises that awoke the governor and his wife each night. The sound was a loud rapping on the wall where the headboard of the old bed had stood. Scott ignored the noises, but when Governor James E. Holshouser Jr. moved in, he had the old bed moved back to its original location and the rapping noises stopped.

In the 1920s the mansion was remodeled and many of the Victorian features of the house were altered or removed entirely. This included enclosing the porches on two sides to expand the kitchen and security facilities. Stained glass, balustrades and over-the-mantel mirrors were removed. Columns and pilasters were replaced. Extensive renovations were undertaken in the mid-1970s and plumbing, heating and electrical systems were modernized. Air conditioning was installed.

In 1970, the house was listed on the National Register of Historic Places. Now termed the Executive Mansion, a nonprofit corporation (Executive Mansion Fund, Inc.) was established in 1988 to support restoration and preservation and to solicit grants, donations and other contributions.

The North Carolina Governor's Mansion is open for tours. More information can be seen online at http://www.nps.gov/nr/travel/raleigh/exec.htm and http://www.nchistoricsites.org/capitol/exec/exectour.htm.

THE "LITTLE RED MAN" OF OLD SALEM

Perhaps one of the best-known North Carolina ghosts is the "Little Red Man." For over two hundred years, the ghost of the Little Red Man has been seen at the Single Brothers' House in Old Salem. The eighteenth-century town, established in 1766, is now part of Winston-Salem. The Single Brothers' House served as the home for unmarried Moravian males.

The Little Red Man is believed to be the ghost of a man named Andreas Kremser, who was accidentally killed in 1786. Andreas, a shoemaker, was helping a group of men excavate basement space for an addition to the Single Brothers' House. Suddenly, the clay bank gave way and the shoemaker, who was wearing a red coat, was trapped beneath the dirt. He was badly injured and died a few days later.

Entry No. 45 of the Moravian Records of the Salem Congregation states, "The Single Brother, Andreas Kremser, departed early in the morning of March 26th, in the Brothers House here, and was buried on the 27th in our God's Acre."

Kremser was born in 1753 in Gnadenhutten, Pennsylvania. He had come to North Carolina in 1766 to join the Moravian settlements here. Being small of stature, Andreas had worked as a chimney sweep. After he was criticized for his work, he countered by criticizing the construction of the chimneys and stated that there was too much work for one person. He then worked in the kitchen of the Single Brothers' House before he became a shoemaker.

After Kremser's untimely death, residents, guests and visitors often heard a shoemaker's tapping sounds. Many told of seeing a little man in a red coat vanishing around corners.

The society of the Moravians changed over the years and the Single Brothers' House became a home for widows. There were rumors of sightings of the Little Red Man on the roof of the Single

The Single Brothers' House in the village of Old Salem where the Little Red Man has been seen. *Courtesy of the Forsyth County Public Library Photographic Collection.*

Brothers' House. Over the years, the widowed ladies living in the house where Andreas Kremser had been killed reported seeing him. No one tried to convince them otherwise because the stories gave the widows something to talk about.

A young lady named Betsy was visiting her grandmother in the Widows' House. The child had been rendered deaf from a childhood illness, so she knew nothing about the stories of the Little Red Man. One day she approached her grandmother and said in her halting speech, "Betsy saw little man out there, and he beckoned me to come to him." The grandmother did not know whether the child had just imagined him or if she really did see the ghost of the little man.

Some people wondered why the Little Red Man haunted the buildings of Salem. He was known to have been dissatisfied with his job as a chimney sweep, and perhaps he did not find work in the kitchen challenging. It is unknown whether he succeeded in his

job as a shoemaker, and certainly he failed as a basement excavator. Over the years, has the Little Red Man been haunting the Single Brothers' House trying to find "his place" among the Moravian brethren? Did he blame the brethren for his untimely demise?

When a local man was showing a visitor the deep cellar beneath the Brothers' House, they spotted the Little Red Man. The two men tried to catch the creature and moved to corner him. However, their outstretched arms met only empty air. When they turned around, the saw the Little Red Man grinning at them from the doorway. After that sighting, a visiting minister exorcised the ghost. He called on the Holy Trinity and then commanded: "Little Red Man, go to rest!" Since then, the Little Red Man has been seen no more, or at least there have been no more reports of him.

DEATH AND MYSTERIOUS CREATURES AT THE SHALLOW FORD

In the spring of 1947, green leaves were beginning to sprout from the limbs of the trees. The dogwoods were already in full bloom, and their big blossoms shone like snowflakes through the dark woods. A clear view of the river was blocked in many places by giant poplar trees and underbrush, but occasionally the path led to an open space along the riverbank. The area along portions of the Yadkin River is as wild and rugged as it was centuries ago.

This portion of the Yadkin River near the Shallow Ford is shrouded in history. Pre-Columbian Indians followed buffalo trails across the river at the Shallow Ford. The area along the river provided game for both Indians and white settlers: raccoon, fox, deer, rabbit, squirrel, mountain lion, bobcats and even buffalo. The river was full of catfish, brim, eel, shad and freshwater mussels. At various points along the river, the Indians constructed V-shaped stone dams, into which they herded fish. Some of these fish traps can still be seen from the air.

Beginning in the eighteenth century, pioneers poured south down the Great Philadelphia Wagon Road to find new and fertile land. Many of their heavily loaded wagons crossed the river at the Shallow Ford. Evidence of that migration can still be seen in the deep roadbed that climbs the steep west bank to the little village of Huntsville, established in the 1790s.

In October 1780, Tories led by Gideon Wright crossed the Yadkin River at the Shallow Ford. They encountered a group of Patriots on the other side and a skirmish occurred. The Tories were defeated, and fourteen of their number were killed. The Patriots lost only one man. The local legend of the "headless horseman" probably stems from this encounter.

The following spring (1781), the British general, Lord Cornwallis, and his redcoats used this crossing in their pursuit of American

General Nathanael Greene. Greene had crossed at the Trading Ford near Salisbury, but because of spring rains, Cornwallis was forced to move up the west bank to the Shallow Ford before he could cross.

In March and April 1865, the Yadkin River was crossed several times by the Union cavalry of General George Stoneman. They were ordered to destroy anything that could be used to support the Confederate army. Stoneman's men raided all the plantations on both sides of the river. They emptied countless numbers of smokehouses for cured meat and carried off livestock, horses and mules. They burned the Red Store in Huntsville, but under the leadership of Union brigadier general William Palmer, the homes of the citizens were spared.

By the twentieth century, a bridge had been built across the river and the Shallow Ford was no longer used as a crossing place. Even today, the wild, untamed area around the Shallow Ford is a dangerous place, but that isolation has always attracted hunters and fishermen who wanted to escape from the noise and bustle of city life.

FISHING IN THE YADKIN RIVER

For eons, the Yadkin River has been frequented by hopeful fishermen. On any hot summer day, one or more persons could be seen sitting on the riverbank in the shade, watching their poles and waiting for a big catfish to bite. A young boy was fishing at the river when he heard the fighting between the Tories and the Patriots. As a boy in the early 1800s, Thomas L. Clingman (later a United States congressman and brigadier general in the Confederate army) fished in the river.

Some fishermen preferred to go out on the river in shallow-draft boats. The more adventurous fishermen sometimes walked into the river to an old mill dam where the fishing was usually good. Sometimes, groups of men would use a large net to seine the river. Fearless fishermen often grappled under rocks to catch fish with their hands. Of course, there was always the danger of catching a snake or a terrapin instead.

One popular method was to catch fish in a basket made from white oak strips. Once the fish entered the basket, it could not find its way out. Another method was to string a "trot line" across the river. I remember my father and his friend, Bill Dinkins, going out in a boat on the river to check the "trot line," which had fish hooks placed at intervals baited with balls of dough.

TRAGIC ACCIDENT

On a spring day in 1947, I had come with my father down a path through the woods toward the Shallow Ford. We, along with many others, had come because a man had recently drowned in the river and his body had not been found.

Daniel Webster Ireland was fishing in the Yadkin River some distance south of the bridge. He was with a group of seven people from the Hamptonville area of Yadkin County. Years ago, a rock dam had been built in the river to channel the water to run the now deserted gristmill. Ireland and his friends made their way along the dam from the east bank in Forsyth County. The fishing that day was good, and soon the group had all they wanted.

The fishermen turned and started back to the Forsyth County side. Ireland stopped to empty the water from his hip boots before starting back. He was about one hundred feet from the west bank.

Robert Underwood, a member of the fishing party, recalled that after Ireland emptied his boots, he started back across the river carrying about twenty to thirty pounds of fish. Underwood said he did not know what happened, but Ireland suddenly disappeared in the muddy water.

Fishermen who were familiar with the river at that point knew that the water ran swiftly as it passed the old dam. It was also deep at that point, and on this particular day, the water was higher than usual because of recent rains. Some of Ireland's fishing buddies believed that his foot must have slipped on the rocks of the dam. Others believed that the swift water caused him to lose his balance. Daniel Ireland had fished below the Shallow Ford many times. He knew the dangers, but if he fell in the water, he would have been

Old log house near the Shallow Ford where my father, Boone Harding, spent many happy hours. *Courtesy of Lupton Wood, photographer.*

pulled down because of his hip boots and the weight of the fish he carried.

The authorities were notified of Ireland's disappearance and a search was begun almost immediately. On Wednesday, the third day after the accident, the Elkin and Winston-Salem rescue squads began dragging the river with grappling hooks. Other rescue squads came from Lexington and as far away as Roanoke, Virginia. A $200 reward was offered to the person who found the body. The search for the missing fisherman continued for several days. My uncle, Spencer Bowman, flew his own plane to search for the body from the air, without success. As the search continued, large crowds of people lined the riverbank for several miles. There were rumors that Ireland had had a large sum of money with him when he disappeared. Each day, the number of onlookers increased.

The Harding family, my ancestors, had lived in Huntsville for several generations. Although he lived in Yadkinville, my "gentleman farmer father" cared for the ancestral land and had a heard of Black Angus cattle. He loved hunting for rabbit, fox and raccoon (at night). On many cold November mornings, my father waited patiently, rifle in hand, crouched in a blind on the bank of the river waiting for the geese. Each year, the geese made a stopover on an island in the Yadkin River on their journey from Canada to a warmer climate in the South. One goose he shot had a band around its leg that gave its place of origin in Canada.

My father knew every inch of the land around the Shallow Ford and every old road, now overgrown trails, leading down to the Shallow Ford. He spent many hours relaxing in an old log cabin away from the stress of being a practicing attorney, and he never missed an opportunity to go to Huntsville.

That was how my father and I came to be among the thousands of onlookers who were waiting for Ireland's body to be found. When we arrived at the riverbank near the old dam, we were told that the searchers had not found the body. We did not remain long at the scene but made the long trek back up the hill through the dark woods to the road where we had left our car.

I knew there were dangerous snakes in this wilderness—water moccasins, copperheads and perhaps rattlesnakes. But I was not

prepared for what I saw that day. As we were climbing the hill to where our car was parked, I thought I saw a huge snake racing away through the carpet of leaves. That snake must have been fifty feet long and at least a foot in circumference. It was the size of an anaconda, but pythons and anacondas did not live along the Yadkin River. I could not believe my eyes; a snake that size simply could not be real. I decided it must have been an apparition or my mind was playing tricks. But just to be sure, I ran to keep up with my father and took hold of his hand.

Ireland's body was finally found a week after he went under the water. It surfaced about a mile below the dam. His date of death was listed as April 21, 1947, on his death certificate.

I always wondered if there was some connection between the huge snake I saw and the death of Mr. Ireland. Did that monstrous snake live beneath the muddy waters of the Yadkin or on the shore? In many cultures, snakes are associated with rivers, lakes and springs. Perhaps the large snake I saw was sent by the Indians to guard the river and to devour those who did not respect the water or its creatures.

FORTUNETELLING METHODS AND SUPERSTITIONS

R ecently at a family reunion, I was talking to Mrs. Goldie Starling, who just turned ninety years old. She recalled that there had been a woman in her family who could tell fortunes. She said that the woman's name was Margaret and she lived with her niece in the Smithtown/Siloam/East Bend area of Yadkin County. I had heard the same story, but I was told her name was Angeline Lineberry. (See story entitled "A Mischievous Witch.")

COFFEE GROUNDS RATHER THAN TEA LEAVES

In order to tell a fortune, Margaret would pour "sawmill" coffee into a cup. When all the coffee was gone, some of the coffee grounds would be left. She would then take the cup and turn it upside down onto a saucer. After turning the cup around several times and muttering some sort of spell, the cup would be set upright. The pattern of the coffee grounds would then be examined and someone's fortune would be revealed. This is a method similar to reading tea leaves.

PALM READING

Another popular means of fortunetelling is palm reading. The county fair always had a tent where those wishing to know their future could have their palm read by a "genuine" gypsy fortuneteller.

When I was about twelve years old, my father took me to the fair in Winston-Salem. As we walked along the sawdust-covered avenue, an old woman who sat in front of a small tent beckoned me to come to her. I was curious, so I went over. She asked me if I would like to know my future.

Naturally, I replied, "Yes."

So I gave her a quarter and she invited me into her tent. There, by the light of a kerosene lantern, the old woman took my hand and peered at the lines that crossed my palm. After a few moments of silence, the old woman looked up and smiled.

"You will marry a man with dark hair...and have six children."

I really did not believe her, but I politely said, "Thank you," and left the tent.

I assumed she told that same story to many young women. In the 1950s, before the days of birth control, most women did have large families. She did not have to see into the future to predict that would happen.

But many years later, after I had married a dark-haired man and did indeed have six beautiful children, I recalled the old woman's prediction. Had she made a lucky guess, or did she see something in the lines of my palm?

THE COLOR OF MY TRUE LOVE'S HAIR

I don't recall when I learned how to do this little bit of fortunetelling, or who told me. Perhaps I heard it from my granny. She knew all kinds of useful bits of information. I do vividly remember trying out the method.

Conditions had to be just right—it had to be raining while at the same time the sun was shining. On such a day, you had only to walk backward three steps, turn around and pick up a small rock or stone. Beneath it would be found a hair. If it was black, then your true love would have black hair. The same was true for other hair colors.

At twelve years old, I still believed in lots of things. I knew that if I went out in the middle of the unpaved road in front of my house I would be able to prove or disprove this ancient method of telling the future. So I waited through the summer, and one day a warm rain came down for several minutes. Then the sun came out but the rain continued. I knew this was the perfect time to prove or disprove the old saying.

The county fair where the gypsy told fortunes.

I walked barefooted into the road, my arms and legs tanned a cinnamon color from the relentless summer sun. I took a deep breath and tried to remember the exact steps that were required. I closed my eyes and took three steps backward. I stopped, turned around, opened my eyes and looked down. Amazingly, there was a small rock right at my feet. I picked it up and, sure enough, beneath it was a single hair, the color of midnight.

Just as this fortunetelling method predicted, a few years later I married a man with very black hair. I would not tell a lie about something as important as this. Try it and see if it doesn't work every time.

A GLIMPSE INTO THE FUTURE

This method of looking into the future was often tried by young girls in the county. At midnight, the girl would have only to set a glass of water on a Bible. Then, holding a mirror, she would look into it at the glass of water behind her on the Bible to see what the future held. Each girl saw something different. Some saw a coffin, others a white horse, others a man's face. I believe that this method is supposed to work best on Halloween.

THE WEDDING CAKE METHOD

For many, a wedding is a time for hope. It was a custom that each of the bridesmaids who took part in the wedding would be given a piece of the wedding cake to take home. That night, the piece of cake would be placed under the girl's pillow, and she would dream of her future husband.

LOCAL SUPERSTITIONS

Carl Casstevens grew up on a dairy farm. He recalled that his father and every dairy farmer in this area believed, without a shadow of a doubt, that if they killed a toad, their cows would give bloody milk.

A CURSED GRAVE

Junior Casstevens, another relative of my husband, declared that if a person was drunk when he died, no grass would grow on his grave. To prove his point, he pointed to four graves at a local church.

LIFE SPANS

If a person was in good health, he or she was believed to live seven years longer than his or her parents. Thus, if a woman's mother lived to be eighty-five, she could expect to reach the age of ninety-two.

RABBIT'S FOOT LUCK

It has long been a practice to carry the left hind foot of a rabbit in your pocket to bring good luck.

HORSESHOE LUCK

Some people hang up a horseshoe over a door for good luck. The horseshoe must be placed up like a "U" or else the luck will run out.

NEVER WALK UNDER A LADDER

It seems that this is an ancient, universal superstition. One never, ever walked beneath a ladder. If one did so, bad luck would follow. This superstition is believed to have something to do with the triangle the ladder makes when leaned against the wall. Walking beneath the ladder breaks the symbol of the Holy Trinity.

BLACK CATS

In medieval Europe, black cats were associated with evil. The black cat was supposed to be the familiar of a witch. If a black cat crossed the road in front of your automobile, it was recommended that you immediately make a large "X" on the windshield to prevent bad luck.

However, in ancient Egypt, cats were revered. Cats were so treasured that they were mummified and buried in the same tombs as dead Egyptians.

REMEDY TO STOP BLEEDING

There is a method that can be used to stop serious bleeding before Emergency Medical Service personnel arrives, or before an injured person can be taken to the emergency room of the hospital. A verse in the Bible, if read out loud, is supposed to stop bleeding. That verse is Ezekiel 16:6: "And when I passed by thee, and saw thee polluted in thine own blood, I said unto thee when thou wast in thy blood, Live; yea, I said unto thee when thou wast in thy blood, Live."

I cannot vouch for the validity of this method because, thankfully, I have never had to use it, but I do keep my Bible marked, just in case.

TO TAKE THE PAIN OUT OF A BURN

For minor burns, a remedy can be found inside the refrigerator. Simply apply mustard, the kind we like on our hot dogs, to the burn. The mustard instantly soothes the pain. Another remedy is to run cold water over a minor burn. I have tried both of these methods and they seem to work, but only on minor burns, not second- or third-degree burns.

TO WARD OFF EVIL SPIRITS WHEN SALT IS SPILLED

From my earliest childhood, I remember that if anyone turned over the saltshaker and spilled some salt, immediately it was mandatory to pick up a few grains and throw them over your shoulder. This was believed necessary to appease any evil spirits who might be lurking, eager to steal all the salt.

The right hand was deemed the good hand and the left was thought of as sinister. Thus, the spilled salt was picked up by the right hand and tossed over the left shoulder. This was to blind the devil, who might be sitting on your left shoulder, or to keep him from sneaking up on you while you cleaned up the spilled salt. The classical image from paintings and drawings shows the devil as an imp sitting on a person's left shoulder, while an angel often was shown on the right side. To spill salt was a grave error and left one vulnerable to the devil.

This superstition probably goes back to prehistoric times when salt was worth its weight in gold and had to be guarded at all times. Because of its necessity in preserving food, salt had great value and has been used as currency.

Many times, I have spilled salt while eating in my parents' and grandparents' homes. No one laughed or made fun if I tossed a few grains of salt over my shoulder. The practice was as accepted as saying the blessing.

BIBLIOGRAPHY

Barrett, John G. *The Civil War in North Carolina*. Chapel Hill: University of North Carolina Press, 1963.

Beach, Peggy. "Battle of Kings Mountain." http://www.ccncgov.com/battle_of_kings_mountain.htm.

Bishop, Brenda. *1860 Yadkin County Federal Census*. Typescript, privately published, 1983.

"Bostian Bridge—Statesville, NC, August 26/27, 2006." http://charlotte-area-paranormal-society.info/bostian.htm.

"The Brown Mountain Lights." http://www.ibiblio.org/ghosts/bmtn.html.

Brumfield, Lewis. *Historical Architecture of Yadkin County, North Carolina*. Winston-Salem, NC: Winston Printing Co., 1987.

Casstevens, Frances H. *The Descendants of Solomon Lineberry*. Winston-Salem, NC: Hunter Publishing Co., 1968.

———. *Ghosts and Their Haunts: The Legends and Lore of the Yadkin River Valley*. Charlotte, NC: Catawba Publishers, 2007.

———, ed. *Heritage of Yadkin County, North Carolina*. Winston-Salem, NC: Hunter Publishing Co., 1981.

———. *Tales from the North and the South: Twenty-four Remarkable People and Events of the Civil War*. Jefferson, NC: McFarland & Co., 2007.

Casstevens, William C., and Frances H. Casstevens. *Descendants of Thomas Casteven: A Genealogical History*. Winston-Salem, NC: Hunter Publishing Co., 1977.

Executive Mansion Fine Arts Committee. *The Executive Mansion, Raleigh, North Carolina*. Raleigh, NC: Executive Mansion Fine Arts Committee, 1968.

Harden, John. *Tar Heel Ghosts*. Chapel Hill: University of North Carolina Press, 1954.

Holcomb, Brian. "The Tales of Booger Swamp." Typescript, Forbush High School, Tar Heel Junior Historians, 1999.

Hoots, Carl C. *Cemeteries of Yadkin County, North Carolina*. Spartanburg, SC: Reprint Co., 1985.

Kyle, Mrs. Hugh G. "Glenwood and the Old Glenn Ferry." *Yadkin Ripple,* January 24, 1929.

Lankford, G. Wright. "Around 'Glenwood,' Tyre Glen's Home in Yadkin County, Linger Memories of the Old Southern Days." *Yadkin Ripple,* November 12, 1925.

McCracken, Anne Whitaker. *1880 Federal Census of Yadkin County, North Carolina*. Marietta, GA: Chestnut Ridge Research, 1991.

Prim, Clinton. "Tabitha Holton." In *Heritage of Yadkin County, North Carolina*, edited by Frances H. Casstevens, vol. 1, 417–18. Winston-Salem, NC: Hunter Publishing Co., 1981.

Reevy, Tony. *Ghost Train: American Railroad Ghost Legends*. Maceline, MO: Walsworth Publishing Co., for TLC Publishing, 2001.

———. "The Ghost Train of Bostian's Bridge." *Tar Heel Junior Historian* (Fall 2008), 36.

Renegar, Michael. *Roadside Revenants and Other North Carolina Ghosts and Legends*. Fairview, NC: Bright Mountain Books, Inc., 2005.

Rutledge, William E., Jr. *An Illustrated History of Yadkin County, North Carolina*. Yadkinville, NC: privately published, 1965.

"Western NC Attractions: Brown Mountain Lights." http://www.westernncattractions.com/BMLights.htm.

Winkle, Michael D. "Up These Heights and Down These Hollows." http://www.prairieghosts.com/hollows.html.

Yadkin Ripple. "Body of D.W. Ireland Is Recovered Sunday." May 1, 1947.

———. "Huge Crowd Views Ski Show Sunday." June 22, 1961.

———. "Search Is Continuing for Hamptonville Man Who Drowned Monday." April 24, 1947.

———. "Yadkin County is Rich in History: Some Important Things of Former Days." November 12, 1925.

NEWSPAPERS

Charlotte News & Observer
Winston-Salem Journal
Yadkin Ripple

PUBLIC RECORDS AND ARCHIVES

"The Papers of Tyre Glen." Special Collections, Duke University,
Durham, North Carolina.
Yadkin County, North Carolina. Marriage Records, Deeds, Death
Certificates and Wills.

ABOUT THE AUTHOR

Frances H. Casstevens, genealogist and local and Civil War historian, is a retired research assistant from Bowman Gray School of Medicine. She holds an MA in history from the University of North Carolina at Greensboro. She has compiled a book of ghost stories, haunted houses and mysterious, unexplained events from the Piedmont section of North Carolina. Most of the stories in this book came from her own personal experiences or those of her children and friends.

Casstevens has been given the Willie Parker Peace Award by the North Carolina Society of Historians for several of her Civil War books. Her first book on this topic, *The Civil War and Yadkin County, North Carolina*, was written to enlighten twentieth- and twenty-first century readers about what the civilians, as well as the soldiers, endured during that conflict. It was one of the highlights of her life to have a book accepted by a publisher. That book continues to be in demand and has been reprinted in paperback by McFarland & Co.

Casstevens is a lifelong resident of Yadkinville, North Carolina. She is proud of her six children and six grandchildren.

She has served as the past president of the Yadkin County Historical Society, Inc., Preservation Yadkin County, Inc., and was chairman of the committee appointed to celebrate Yadkin County's 150th anniversary. At one time, she played a bass fiddle in her husband's bluegrass band, the Bluegrass Masters.

Since her retirement, Mrs. Casstevens spends her time reading, doing research and writing. She is currently working on a novel set during the 1860s and is planning to write a fictional murder mystery.

ABOUT THE AUTHOR

OTHER BOOKS BY FRANCES H. CASSTEVENS

The Civil War and Yadkin County, North Carolina
Clingman's Brigade in the Confederacy, 1862–1865
*Death in North Carolina's Piedmont: Tales of Murder, Suicide and Causes
 Unknown*
The Descendants of Solomon Lineberry
Edward A. Wild and the African Brigade in the Civil War
*George Washington Alexander and Castle Thunder: A Prison and Its
 Commandant*
Ghosts and Their Haunts: The Legends and Lore of the Yadkin River Valley
Heritage of Yadkin County, North Carolina, Vol. I
Out of the Mouth of Hell: Civil War Prisons and Escapes
Yadkin County, North Carolina: The First One Hundred Years.